P9-CMT-102

100
WAYS
TO MAKE GOOD
PHOTOS **GREAT**

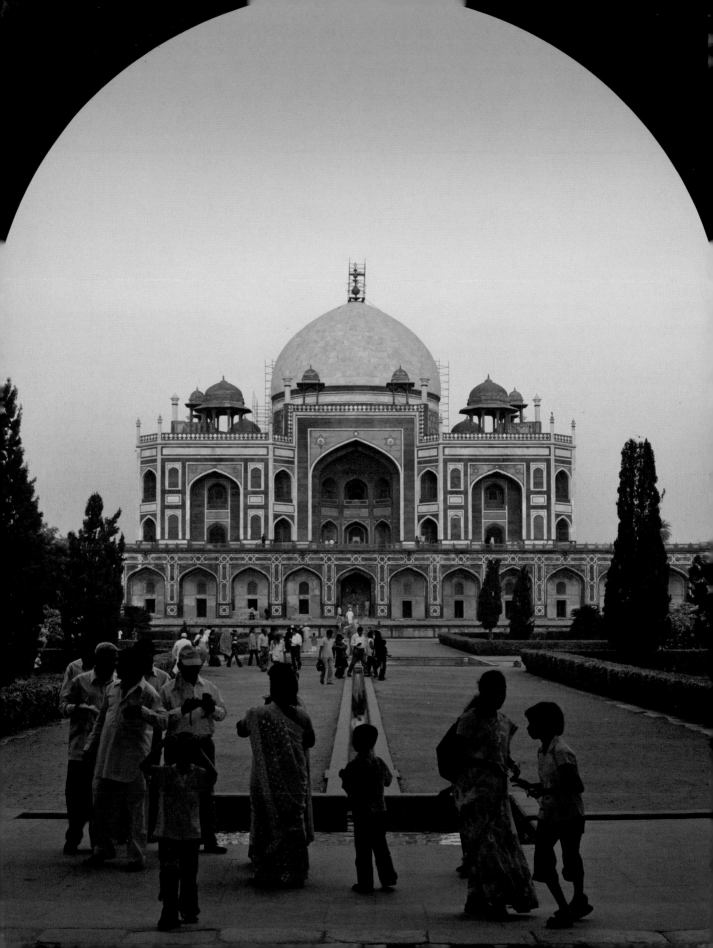

DEC 16 2013

100 WAYS

PETER COPE

TO MAKE GOOD PHOTOS GREAT

TIPS & TECHNIQUES FOR IMPROVING YOUR DIGITAL PHOTOGRAPHY

David and Charles

ACKNOWLEDGMENTS

This book has been a team effort. Some talented people have helped to conceive and develop it, and I would like to acknowledge their help and support here.

It was Judith Harvey, the Creative Arts Community Leader at F+W Media, who helped me visualize this title and, over some great lunches, helped to shape it.

To make a book that's entertaining and informative needs more than my words. So I am grateful to Assistant Editor, Hannah Kelly for going beyond her role to keep everything focused, together and on track.

I'd also like to acknowledge the creative work done by Sarah Clark, designer of the book. Good design can make or break a book, and I am pleased Sarah has done such a splendid job.

And my thanks must also go to Freya Dangerfield for making the book so readable. Sometimes when I write, my passion runs away with me so it's good to have Freya there to sort out my words and (occasionally) disappointing grammar.

Finally, can I thank everyone at F+W Media for our continued partnership and for being such a friendly and professional publisher to work with.

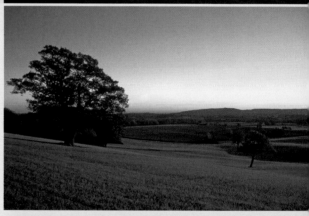

PHOTOGRAPHS AND IMAGES

I'd also like to thank the following companies and people for allowing me to use their images:

Lastolite: for images of their renowned reflectors and diffusers along with the results they produce

Celestron: every astronomer will know their name – for the images of their great astrophotography kit

Sarah Cope: my daughter – for her great photos of Iceland

DEDICATION

For Heather, without whom I'd not have my wonderful Gill or fantastic children

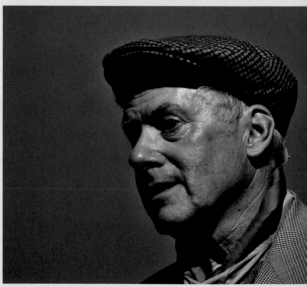

CONTENTS LIST

INTRODUCTION

We're going on a mission – to banish mediocrity and to shoot photos of which we can be proud and others envious. Is this a tall order? Not at all. In fact, don't think of it as a mission so much as an adventure into the art, the science and particularly the fun of photography.

Today, cameras are ubiquitous. Wherever people gather you can be sure a fair number of them will have a camera – or camera phone – raised, recording anything and everything around them. Recall for a moment the summer of 2012, when exciting, emotional and iconic images of the London Olympics flashed around the world across all kinds of media platforms.

What made these images unique and different from those that press photographers have gathered at events for a century or more is that most came from amateur or casual photographers. They were grabbed shots, photos taken on a purely opportunist basis. Now that just about everyone has the chance to record an image whenever and wherever, fantastic photo opportunities are rarely missed.

Often, though, little thought goes into shooting photos; the term 'point and shoot' has become particularly apt. For many of those taking photos, ultimate quality is not the most important factor. Instead, as well as the photos they take serving to provide a record, like favourite music tracks the

Cameras everywhere: You'll find people shooting photos everywhere – and with kit that ranges from a simple camera phone through to that normally the preserve of professionals. On it's own, great kit does not guarantee great photos; there's a degree of skill or old-fashioned nous needed, too.

purpose is also to trigger happy memories.

However sometimes we will want something more – photos rather than snapshots; that's where this book comes in. Here we'll look at ways – often simple ones – to create great photos that will be more emotive and meaningful to us. This is not a photo manual, so we're not going to spend a lot of time defining rules and formalities; rather it's about discovering that the fun of photography and developing the skills to shoot compelling photos need not be mutually exclusive.

We'll cut, too, through the mystique in photography. Photographers can become presumptuous and – dare I say it – even pretentious about images. They can demand that every shot they take and every photo they critique must be meaningful. Not only must these images be technically correct in terms of exposure, focus and composition, they must also say something to us – they must have purpose.

This is a laudable attitude and is certainly one with merit, but for many of us it can be restricting. Anguishing over taking a photo can mean we lose the moment and the spontaneity. Sometimes we just want to take photographs for fun, or for our own enjoyment. These photos will not win any competition or gain plaudits from our peers, but then they are not intended to. Yet they will become treasured, and there's no reason why they should not be good photos.

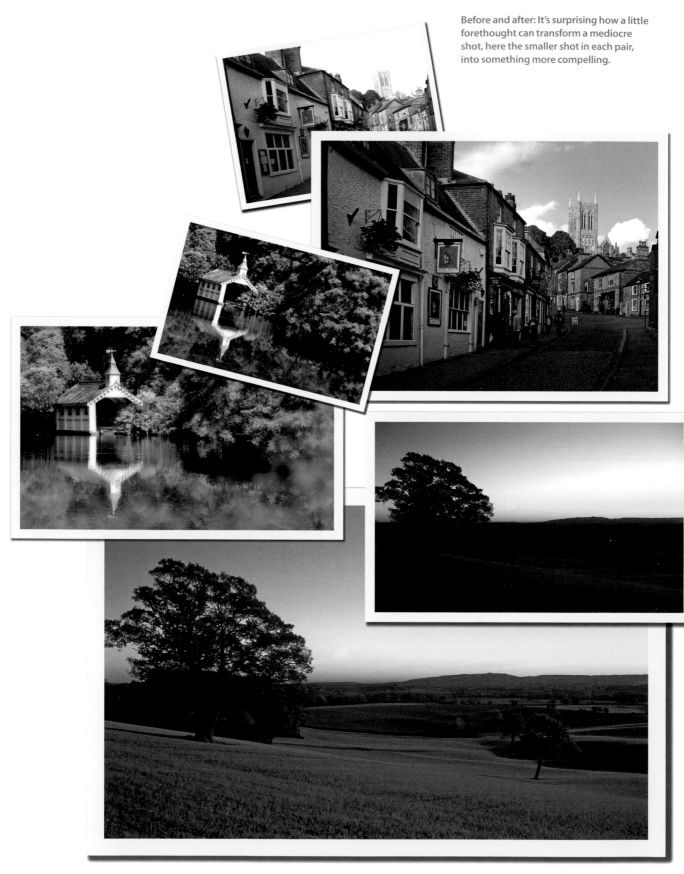

Before and after: It's surprising how a little forethought can transform a mediocre shot, here the smaller shot in each pair, into something more compelling.

So, then, what is it that makes the photos you shoot good rather than great? Of course, it can be any one – or more – of a number of things. It could be that your camera has predicted the optimum settings to use to the best of its ability, but those settings are not entirely appropriate. In this book we'll investigate those situations where you are safe to leave the camera to its own devices and those when you need to intervene. It may be that you've positioned your subjects well in the frame of the viewfinder, but you could have done so to better effect. Or it may simply be that you've not exploited the colour, the light or the subjects in your scene.

Whatever the reason, we'll look at the cause and how you can do better. We'll be taking a holistic approach, using in camera and image manipulation software as appropriate. What we won't be doing though, is using image manipulation software – whether on a computer, tablet or in your camera – as an excuse for accepting mediocre shots. Image manipulation software can make a good photo great, but should not replace sloppy technique.

I want to add a note about the photos used in this book. Often books that explore photographic technique use photos shot on the most professional cameras and post-processed to deliver perfection. This can be good as it provides inspiration, but it can also be a little intimidating, as the images appear so good that it's hard to emulate or equal them. So, for this title all the photos used in the examples have been shot using either amateur or enthusiast cameras – nothing exotic, nothing out of the ordinary. In fact, they are images that, once you've gleaned the essentials from this book, you could well be shooting yourself!

Shooting photos is fun and can be compelling. Never lose sight of that. Let's just make sure our photos can be something to be justifiably proud of too!

CAMERA PHONES
Camera phones have played a dramatic role in increasing the number of photos shot daily around the world. However, do they stack up well against conventional cameras? In some respects they do, in others less so. In yet more situations they can do things conventional cameras can't. So in this book we've highlighted some situations where your camera phone might give you a bit of an advantage – and the occasions where you might need to rethink your approach. One thing is clear though, don't knock camera phones; they will open the door to opportunities other cameras won't.

EXPLOIT THE DIGITAL ADVANTAGE

For many photographers, film photography is but a distant memory – along with its limitations dictated by the fact that you couldn't see your image until the film had been processed and you could only shoot to the amount of film stock available. For others it's just something from the history books. However it's worth recognizing – and acknowledging – the advantages digital cameras can bring to photography, as they are a significant boon in helping us conceive and shoot great photos:

- **Instant feedback:** The LCD monitor on your camera lets you review your images immediately – particularly useful when attempting to master techniques such as composition and exposure compensation.

- **Negligible costs:** No longer does the film you can carry (or can afford) limit your photo shoots. Practically, that means you can shoot more – and experiment more – without incurring any expense.

- **Shoot in variable conditions:** Loaded with film, a camera could be limited to either outdoor or indoor shooting (without the use of corrective filters) and light levels. Digital cameras let you adjust for different lighting types and lighting levels with ease.

- **Record data:** Data relating to every shot you make is automatically encoded, making it easy to find the particular camera settings – and even location – where shots were taken should you want to repeat a particular technique.

- **Simple improvement:** Making a film-based image better was a skilled darkroom art, and darkroom work had to be done, effectively, blind. Now you can improve (and, let's face it, potentially wreck!) images in real time using digital manipulation software.

- **Store images:** Forget the proverbial shoeboxes filled with snapshots and negatives. You can now store all your images conveniently, and create backups of your entire library as insurance against your computer failing equally conveniently.

- **Share images:** You don't need to mail photos of significant events to people – often so long after the event that the moment is lost. You can share instantly via email, web photo galleries and social media sites.

Camera phones: They may be limited in their scope and control, but don't dismiss camera phones. Situations will arise when a camera phone is the only option – where conventional cameras are banned, for example. And in the right hands you can still get some great shots.

CHAPTER 1:
TURNING THE GOOD
INTO GREAT

It's surprising how ideas and inspiration for books sometimes begin. For this one, it was being asked to look at a collection of photos. This might seem a perfectly innocuous activity, but while doing so you can find yourself in a somewhat difficult position. Asked to comment on a collection of obviously prized images, it is hard to be truthful. Viewing with the critical eye of a photographer, I tend to view such collections in a rather clinical, technical sense, noticing the poor composition, wincing at tiny subjects almost beyond recognition, and being drawn to the lack of critical focus in many of the shots.

Of course I would never – unless the photographer compelled me to do so – openly criticize or point out shortcomings. To many photographers shooting is about recording events and saving memories: a child's first steps, the last picture together of two loved but departed family members. In these circumstances many people care less about what the shots look like, rather that they just want a permanent record of the event. However, when people are obviously keen to capture these images, wouldn't it be great if they could record their best memories with truly excellent photos instead of the merely good?

In this section we'll work on the premise that everyone wants to shoot great photos, but often just need a little direction and guidance to do so. So let's begin by looking at some simple – and seemingly eclectic – ways that we can start turning our photographic snaps into photos: interesting images into compelling ones, emotional photos into emotive ones. Not all photos need to stand up as exemplars, but it's amazingly satisfying when a snapshot turns out to be a great photo, one that can draw plaudits not only from friends and family but from other photographers, too.

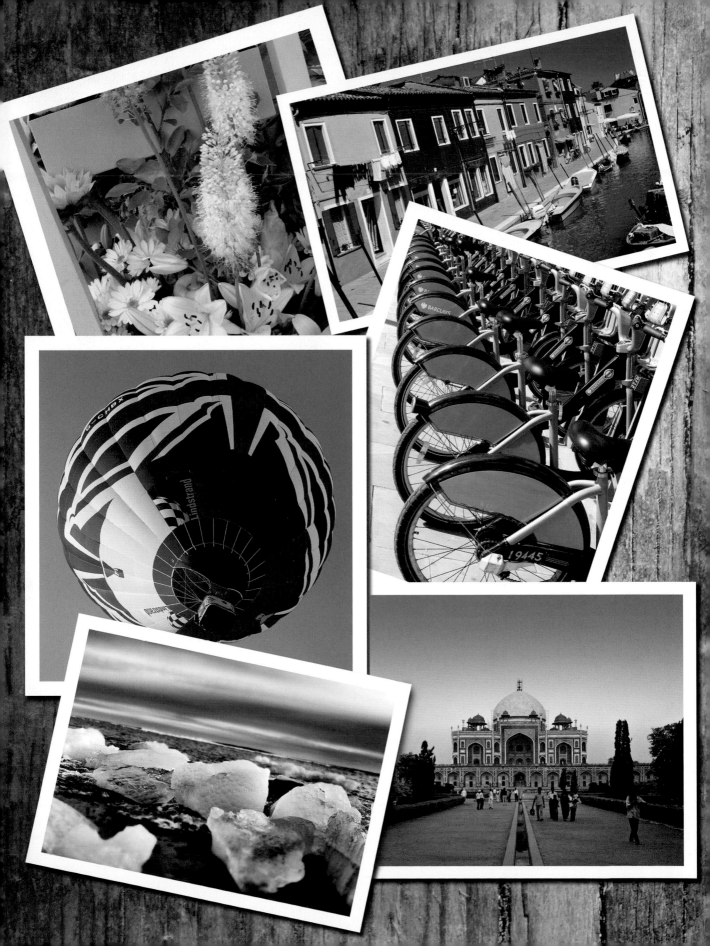

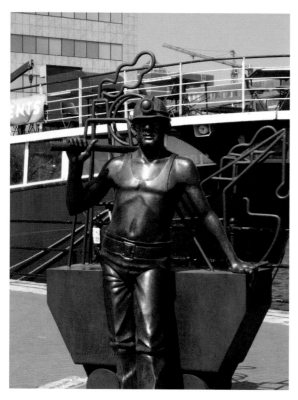

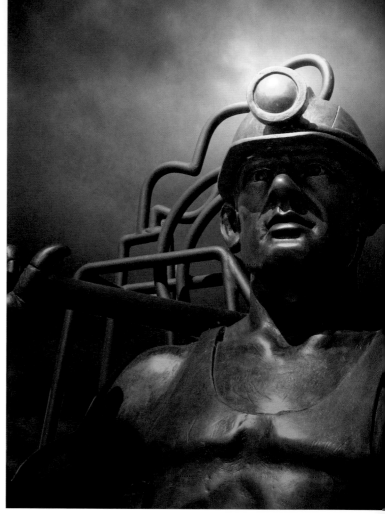

1 DEVELOP A PHOTOGRAPHER'S EYE

When does a good photo become truly great? What elusive qualities help it make that transition from a photo that's pleasant, to one that makes you sit up and look at it more closely? Of course there is no magic formula – otherwise we would all be shooting great photos all the time – but there are a number of cues to follow.

A good starting point is to analyse what makes a great image. What has the photographer done to make an image excel? Consciously – or more likely subconsciously – the photographer will have run though a checklist and asked him- or herself a question or two before finally pressing the shutter.

The first question might be 'Why am I about to take this photo?'. Standing in front of the Eiffel Tower, the answer might be 'To prove I've been here', or 'To record all the places I visited on my holiday'. Both

are perfectly valid reasons, but those more typical of a keen tourist photographer rather than a skilled image creator.

In contrast, the more experienced photographer might answer 'Because I like the way that the rust colour complements the green foliage', or 'Because of the warm glow the evening light casts over the scene'. These answers show that the photographer is less interested in recording the scene and instead is looking for – perhaps literally – a new angle. That's not to say you shouldn't shoot more ordinary views too. I always do!

Tourist shot vs creative shot: Here's a powerful yet modest sculpture that celebrates the bygone mining industry and miners of South Wales. The tourist shot is fine, showing the sculpture in situ. However crouching down and making the best of the sunlight and some high cloud provides a much more evocative result. Creating such an image just involves spending some time exploring the subject and making the most of the environment.

So what else might we ask? Here are just a few more questions that might be on a photographer's checklist before pressing the shutter. Don't worry if the merits are not yet clear, rest assured we'll cover them all soon. The more we can take on board, the better developed our photographer's eye will be, so here goes:

- **What's the weather like?:** The weather – in terms of the weather conditions and the lighting – will have a significant bearing on the results achieved.

- **Is the subject in focus?:** How much of the shot is in focus? Is this appropriate for my subject? We're talking here about depth of field.

- **Is the shutter speed appropriate?:** This is particularly important if hand holding the camera – to avoid camera shake and blur – or when shooting fast moving subjects, when we may want to freeze or accentuate blur.

- **Have I composed my shot well?:** Composition can make or break an image that is perfect in every technical sense.

This list could go on but let's not labour it any more at this point or you'll think we're making it rather difficult to shoot well. We need to remember that, above all, photography should be fun and enjoyable. We'll see many more ways of sharpening our eye for a great photo in this and future sections – and also see how intuitive many of them are.

Of course in reality we can't get everything right all of the time. We'll be talking later about the part luck plays in getting a great shot, but in the meantime we can start developing that critical eye that ensures all elements – or as many as we can reasonably expect – come together when we press the shutter. Developing a photographer's eye takes time but doing so is never dull.

tip

WATCHING THE WEATHER

Photographers can sometime be obsessive in their interest in the weather – the forecast for their next photo mission can determine whether that mission will be a success or failure. However even when conditions appear to be stable and conducive to great photography, you need to stay alert. Take a look at the following case.

It's a sunny day; with clear blue sky and photogenic fluffy clouds – conditions look ideal for some bright, punchy tourist-style photos. But things can change quickly as those fluffy clouds start to cast a dark shadow over your images. You need to be vigilant and check that what you are shooting through the viewfinder matches the shot you originally conceived.

Being mindful of transient changes in a scene is often important – if not critical. Weather changes represent one case and later we'll be looking at a more creative one: determining the decisive moment.

What a difference a second makes: Fleeting changes in weather conditions can make ruinous changes to the quality of your images, changes it is all too easy to overlook until it's too late. Here's the original shot, where the shadow from a cloud intervened, followed by a shot as the cloud started to move away, and finally the shot as originally envisioned.

2 CHECK THE VIEW THROUGH THE VIEWFINDER

OK, in many cameras today there's not a viewfinder as such – images are presented on a fixed or adjustable LCD screen – but the principle is the same. The viewfinder gives you a pretty accurate representation of what will appear in your photo if you were to press the shutter release at that moment. This is why it's crucial that you properly assess what's on display.

Pro tip

FINE-TUNE YOUR COMPOSITION

By mounting your camera on a tripod (or an equivalent firm support) you can fine-tune the view through your viewfinder. Making the smallest adjustments to the horizontal or vertical alignment can remove distracting elements and produce a more pleasing composition. Not having to worry about holding the camera steady also lets you concentrate more on the image.

Many a good shot has been spoiled through poor composition, a subject blinking, or by holding the camera at an unfortunate angle. Although we can learn to improve composition and overcome other potential problems, it's all too easy to overlook more obvious image defects at the crucial moment. We tend – naturally perhaps – to concentrate our attention on the subject of a photo, remaining oblivious to what is going on beyond.

Digital photography was touted as a solution to poor technique; with it you can take a photo of your subject with a tree apparently sprouting from his or her head and remove it digitally later. And of course you can, but it's much better to avoid such faux pas in the first place. It's good practice to get into a routine of spending just a second or two before pressing the shutter to check the viewfinder for any errant elements. Are there any trees – or lamp posts – interfering with the shot? Is the subject properly placed in the frame, appropriately sized and not too small, with no bits cut off by the edge of the frame?

Trees: Apparently sprouting from a subject's head, trees have long been the bane of the unobservant photographer – I myself have a vast collection. Again, a slight reposition gives a less comic, more successful result.

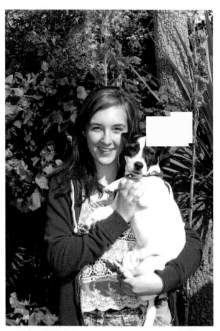

Lamp posts: Like bins and other street furniture, a lamp post rarely adds anything to a shot yet is so easily included if you don't take a second to look around your subject. A quick change in camera position can give a much better result.

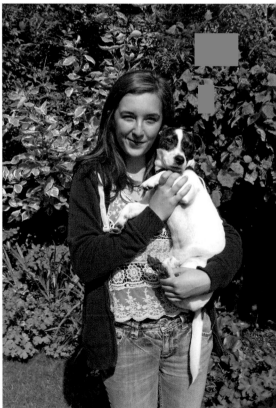

3 KNOW – AND VALUE – YOUR VIEWFINDER DISPLAY

If you're a digital SLR user the viewfinder information display – generally located under the image – can be baffling. Look more closely, though, and things become both clearer and more useful. Get to know just some of the display elements and you can be sure that you'll get the technical aspects of your photos spot on, too.

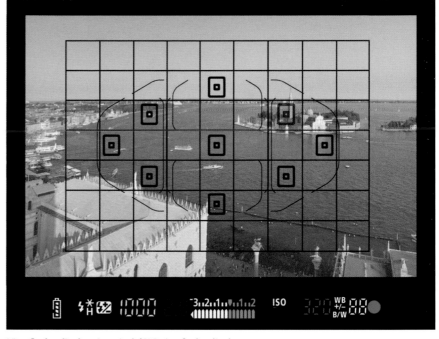

Viewfinder display: A typical dSLR viewfinder display.

Here's a typical display – typical because, somewhat annoyingly to multiple camera users, no two displays are the same. However the indicators on the display are broadly similar no matter what camera model you have. For clarity, different indicators have been given different colours; here's what those numbers mean, and what they mean to your photos:

- **Yellow:** The exposure time – here $\frac{1}{1000}$ second. Shorter exposure times lead to less camera shake but will often require wider apertures and/or increased film speed.
- **Red:** The aperture – here 2.8. Use a wide aperture (such as f/2 or f/2.8) for shallow depth of field, useful to isolate portrait subjects from the background, or use smaller apertures (such as f/16 or f/22) for foreground to background sharpness.
- **Green:** Exposure compensation – here +2 stops. Set an amount of exposure compensation to ensure subjects that are particularly dark or bright are properly recorded and not

over or underexposed (respectively) by the camera's exposure system.
- **Blue:** ISO sensitivity – the higher the number the more sensitive the camera's sensor, allowing shorter exposures. However higher sensitivities can result in noisier, mottled images so lower sensitivities are best for highest image quality.
- **Red rectangle:** More prominent here than it will normally appear, this indicates the focus point. The camera will focus on the part of the image under the red rectangle.
- **Green dot:** When the green dot is lit, the camera is focused.

Of course these are indicators, so they show you the way that the camera is configured. They echo any settings you have made and the corresponding ones the camera has set. It's important that you get to know how to make the settings on the camera – and to be able to do so when the camera is at your eye.

Full display: Although you'll never see every indicator lit simultaneously, there's an awful lot of information you can glean from the display.

4 LEARN THE RULES OF COMPOSITION

I said earlier that I was uneasy with rules in photography; they can lead to photos becoming too proscribed and too formulaic. Yet some rules are there because they genuinely serve a good purpose. The rules of composition are amongst these: if you follow them – at least some of the time – you'll appreciate their value.

Perhaps the best known – almost to the point of being a cliché – compositional tool is the rule of thirds. Cliché it may be, but that's because it works. And it's easy to visualize – as most camera LCD displays can display the appropriate guidelines.

So what is the rule of thirds? Divide your image into three – vertically and horizontally – then you'll have four points where the dividing lines cross. You should place your subject on one of these intersections. If your shot also includes the horizon, you'll get an even better composition if you place the horizon line along one of the horizontal dividing lines.

It's simple, and it's powerful – which is why it's become formalized as 'rule'. But, as with all rules, don't follow it blindly. If a composition works better when, for example, the subject is centred in the frame, shoot it that way instead.

Simplicity should also be a by-word in composition. True, some photos you shoot will be chaotic and will be all the better for the mass of colour and shape. However previously we've mentioned the need to fine-tune a composition to remove any peripheral distractions and it's important that you keep compositions as simple as possible. This makes it easy for anyone viewing your images to instantly recognize the subject and it's placement in the scene.

WATCH OUT!

When you spend time concentrating on getting the composition right, it can be easy to overlook some real faux pas. Allowing the horizon to slope is key amongst these – and is a way to ruin an otherwise perfect shot.

So, as you're about to press the shutter, give a moment's consideration to getting the horizon dead level – unless, of course, you want to use a very obviously tilted horizon for dramatic effect.

Pro tip

FILL THE FRAME

If there's a giveaway to indicate a lack of photographic prowess, it's not filling the frame with a subject. Inexperienced photographers will often grab a shot of a distant subject without moving in close or resorting to the zoom lens. Avoid this problem by making sure you always fill the frame with your subject. Or, if that subject is interacting with objects in the near vicinity, fill the frame with the subject and it's immediate surroundings. Don't be afraid to switch from landscape to portrait format for better effect.

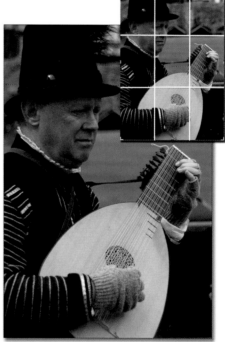

Rule of thirds: Placing a subject – or the key element of a subject – at the intersection of the dividing lines (as with the eyes, here) delivers a much stronger composition than if we had placed the subject more centrally.

Improving composition: The rule of thirds can be applied to almost any scene and gives the image visual strength. It's also a great way to learn how to use all the real estate in the viewfinder.

5 BREAK THE RULES OF COMPOSITION

OK, so we shouldn't place objects centrally in our shots – off centre is best, right? Well, most of the time. Sometimes, though, the power of a subject is lost when you follow the rules too strictly.

A good example is shooting symmetrical subjects: shoot off centre and you'll lose the impact of the symmetry. Place them centrally in your shot and you'll have a much more powerful – if rule breaking – composition.

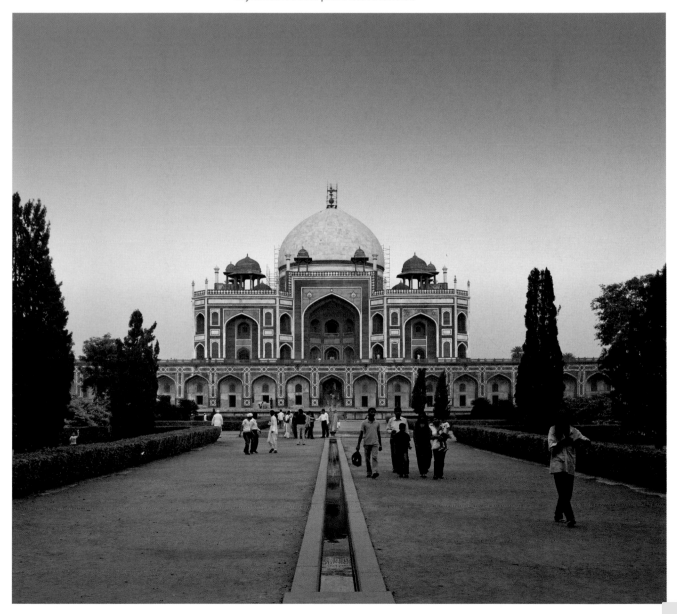

Symmetry: A subject displaying strong symmetry is often best shot as part of an overall symmetrical composition. Huymanen's Tomb in Delhi is perfectly symmetrical and set in equally symmetrical grounds. A symmetrical composition works effectively whereas anything asymmetric would prove less successful.

6 CHOOSE – AND USE – THE PERFECT LENS

Take a peek at photographers along the touchline of sport events and you'll see them using cameras loaded with enormous lenses, carrying backpacks obviously filled with many more. Is this a cue to arm yourself with lenses of every focal length and aperture? Fortunately not – a smaller collection can cover all your everyday needs and prove much more affordable.

So what do you need to get the best from your camera? Often interchangeable lens cameras come with what is called a kit lens (by virtue of it being supplied with the camera), which is a zoom lens with a focal length of 28–120mm (typically). This is sufficient to cover modest wide-angle shots, standard focal lengths and modest telephoto focal lengths. It's not the sort of lens that professionals would value, but that's not to say it's a bad lens. It's a great piece of kit to have on the camera to ensure you're best set for the majority of everyday photo opportunities.

So why isn't this the only lens you'll ever need? There are a couple of reasons. First, the kit lens is built to a budget: to keep costs down, yet the potential image quality high, the maximum aperture is usually small – f/3.5 to f/5.6. This means that when the light levels fall you have to increase the ISO sensitivity or, if viable, the exposure times. Not always ideal if you're dealing with fast moving subjects or shooting in dim conditions. Second – and again dictated by the cost – the zoom range of the kit lens is modest. It's unlikely to be as wide as you might sometimes need (particularly if you want to shoot in tight interiors) and the telephoto range is not sufficient to let you get close in on distant objects.

Should you give the kit lens a wide berth or, if you have one, discard it? Not at all – accept it for what it is and it'll serve you well. Think, though, how you might extend your collection. Here are my suggestions, based on what you might consider your favourite type (or types) of photography. The focal lengths are 35mm equivalents (see Understanding focal lengths).

Focal lengths compared: Here's a quick comparison of popular focal lengths and the magnifying effect they have on an image. The orange box represents a 200mm focal length; the red box, a 300mm.

Kit lenses: With a modest aperture (here f/3.5 to f/5.6, depending on focal length), kit lenses need good daylight to excel but also offer compactness and suitability for a range of situations. Perfect for use as a standard lens.

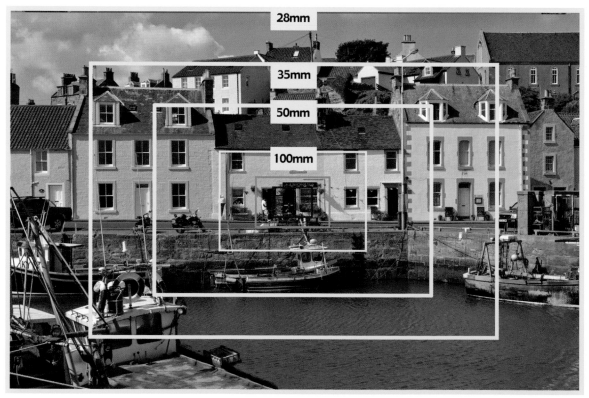

28mm

35mm

50mm

100mm

For general photography you can be well covered with just three lenses:

- **Super wide-angle, 20mm to 40mm:** Great for those tight interior or dramatic outdoor shots.
- **Standard zoom, 28mm to 70mm:** A narrower range than the kit lens, but it covers many everyday situations. A wide aperture, say f/2.8, is moderately pricey but extends the flexibility substantially.
- **Telephoto zoom, 70mm to 200mm, 70mm to 300mm:** Picks up where the standard zoom leaves off and allows you to zoom in on small details in the scene.

If your photographic ambitions include portrait photography and macro photography, it can pay to invest in lenses that are particularly designed for these. A macro lens, which is usually a modest telephoto lens that can focus closer than a conventional lens, can also double up as a portrait lens.

Sports photography demands sharp images of fast moving objects – and that needs large apertures. You need to go for the largest aperture you can afford. You might also, depending on the sport, need extreme telephoto lenses – 400mm or more. And these lenses can get pricey!

Prime lenses – those with a fixed focal length – should also be considered, particularly if you want large apertures. OK, you don't have the ability to frame the scenes in the same way you can with a zoom (see Frame to enhance your photos) but you can often get wide apertures more economically. These are ideal if you want shallow depth of field and enjoy shooting in low lighting conditions.

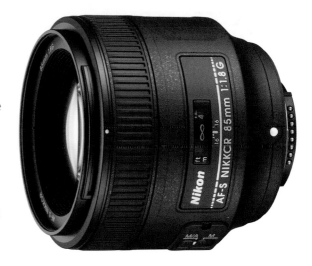

Portrait lenses: A good portrait lens is characterized by a wide aperture (here f/1.8) but needn't be too pricey.

WATCH OUT!

If you use a digital SLR – the equivalent to conventional film-based SLRs – you need to check your sensor size before buying lenses. These cameras can have small sensors, equivalent in size to older APS film cameras, or larger ones, similar to a frame of 35mm film. These are often called DX and FX respectively. If you buy a (usually cheaper) lens for a DX sensor it won't produce a large enough image for an FX sensor. The result will be edge darkening.

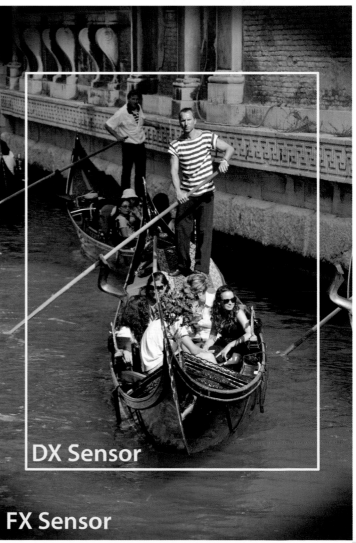

DX Sensor

FX Sensor

 tip

UNDERSTANDING FOCAL LENGTHS
Once the focal lengths of lenses were easy to understand. With 35mm film almost universal, a 50mm lens was considered standard, a 28mm was considered wide angle, and a 70mm plus was considered telephoto. Now with sensors of many different sizes, a 10mm lens for one sensor has an equivalent field of view to a 25mm for another. To introduce a degree of commonality you'll now find many lenses described in terms of a '35mm equivalent'. This makes it easy to compare lenses – particularly if you use more than one camera or cameras with different sensor sizes.

Sensor size: An FX sensor is larger than a DX, and a DX lens won't fill the frame of an FX sensor.

7 FRAME TO ENHANCE YOUR PHOTOS

When you're presented with a wonderful photogenic scene or situation, the natural reaction is to switch on the camera and start shooting. There's nothing wrong with that – and it's good to grab a shot before the lighting or the elements in the scene change. But after shooting these initial shots, take a moment to look within and around the scene to see if there are better ways to frame your shot.

Zoom lenses come in for a bit of stick from professional photographers, who would rather use fixed focal length lenses and adjust their position to best frame their shots. This is based on the sound principle that a zoom lens – even that of the highest quality – is a bit of a compromise. It has to perform at different image magnifications and to do so requires a lot of glass, which doesn't always mean you get the best result at each.

For most of us, though, the advantages can outweigh the shortcomings, and a zoom lens can provide an excellent way of refining and honing the subject of our shot. Zooming in can help trim away distracting elements in the shot or can draw attention to specific subjects. Conversely, zooming out is an expedient way to display a subject in its wider context.

Take a look back though some of the images you've already shot and downloaded to your computer. With image editing software, use the Crop tool to see if you can create new images from elements within the original scene. You can adjust the cropping tool to vary the results until you get a composition you are pleased with.

WATCH OUT!

Don't use a zoom lens in place of some legwork. If you want to get to the heart of some action for example, zooming in from a distance doesn't give the same result as getting in physically close and shooting with a wider lens setting. Photos shot from a distance don't always have the same impact; your distant position can make shots more dispassionate compared with those shot in the thick of it.

Framing and cropping: Zooming in on part of a scene can produce a bold image with a different or complementary character to the original, wider shot (left). Don't be afraid to switch from landscape (wide) to portrait (tall) formats.

⑧ ADD DEPTH WITH FOREGROUND FRAMES

Take a look at many photos, particularly landscapes, and you'll see that professionals use several little dodges to help lead the eye into the scene and provide added depth. One of the most popular – because it is the most effective – is to use a foreground frame.

That foreground frame will be something convenient in the landscape such as a branch of a tree or – a little more literally – a gateway or archway. Try shooting scenes with and without these props and discover the difference they make. To do so, you will probably have to reposition yourself under a tree or through a gateway. In addition, alter the zoom setting on your lens to ensure the subject remains appropriately sized and positioned.

Foreground frames: A foreground frame adds perceived depth to a shot and is effective at leading the eye towards your subject.

Pro tip

NEARBY OBJECTS CAN BLUR
A frame can be close up to the camera, yet does not have to be sharp. Shooting through, or over, nearby foliage can produce a more effective result than if you were to choose a smaller aperture and keep everything pin sharp. The view then emulates that of the human eye, where we focus on the subject, consequently causing nearby objects to blur (see Add depth to an outdoor scene).

⑨ MAKE THE MOST OF COLOUR

Colour is a crucial element of a photograph. Which colours, and how those colours are used, can make or break an otherwise excellent image.

For some photographers there is only black and white. Colour, they will contest, only distracts from the purity of the tone, contrast and form they are so eager to record. I have to admit that I love colour: on one hand it can set the scene and atmosphere of an image, and on the other it delivers a terrific punch. However it's not something that should be taken for granted. Colour needs to be handled carefully if it's not going to dominate your images to the exclusion of everything else.

So how can you work with colour to deliver impact, mood and emotion to your images? There are two regimes that we can use for this – complementary colour and similar colour. Both regimes are based around the colour wheel, a convenient and effective way of demonstrating the relationship between all visible colours. Complementary colours are those found on opposite sides of the colour wheel. Viewed together, they provide bold contrast. Images that feature these colours tend to be energizing and confident – think of reds and greens together, and of blues and yellows. These combinations can also work well at low colour saturations. Beware though, as highly saturated complementary colours can sometimes visually clash.

Similar colours, conversely, describe those that are neighbours or near neighbours on the colour wheel. These are colours that sit harmoniously together and (depending on the colours) can suggest peace and romance.

Pro tip

COLOUR AS AN ACCENT
Capture a small amount of bold colour in a scene otherwise composed of harmonious similar colours to provide a bold accent that immediately attracts attention.

Accent: The bright red flag provides a bold accent to a scene that is otherwise comprised of largely similar colours.

△ Colour wheel: Here you can see that similar colours are adjacent each other on the wheel. On the other hand, complementary colours are those on opposite sides.

▽◁ Complementary colours: The power in the image comes from the contrast between the colours.
▽ Similar colours: These sit well together even when used at high saturations and provide images with coherence.

22

ON YOUR PHONE
You can download a range of apps that allow you to play with colour in your images. Use these to tone down bold colours to something more pastel, or to give brighter colours a real blast. Transforming everyday colour into something more vivid doesn't always provide realistic effects but it can certainly result in powerful images.

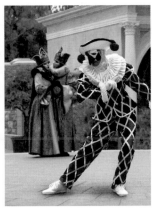
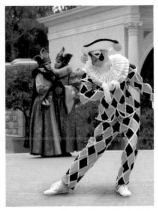

Colour apps: On your phone use colour manipulation apps to change colour from the bold to the lurid.

10 GIVE COLOUR A BOOST

Have you noticed that photos in holiday brochures have bold, deep and inviting colours? This colour intensity – or saturation – makes the scenes more appealing. Give your own holiday photos a stunning 'brochure' appearance by boosting the colour saturation in them.

Just about all image editing applications let you boost the colour saturation of your images to give their colours a lift. Unfortunately, those controls can often give a poor result when you look closely – large swathes of colour become mottled as the Saturation control affects different pixels by different amounts. Instead, use this useful little dodge to achieve great results every time (see also Use exposure compensation to enhance colour). You'll need an image editing application that allows you to use and manipulate layers, but the method is both simple and controllable:

1. Open your image.
2. Copy and paste it into a new layer.
3. Increase the colour saturation (using the Hue/Saturation control) by about 10 or 15%.
4. Apply a Gaussian Blur to this layer so that the image is slightly but obviously blurred.
5. Use the Layer Blend control to blend the two layers together, using the Color option.

Job done – it almost takes longer to describe than it takes to do! Applying the blur means that any mottling you might otherwise get is smoothed away and you add more even, saturated colour. You can also use the Layer controls to fade the amount of contribution to the layer if your original settings result in too saturated a finish.

Boosting saturation: Using layers to do this provides you with more control and a more even result.

11 MAKE THE MOST OF THE LIGHT

Auto Exposure modes are now almost universal in cameras and ensure our photos are properly exposed – most of the time. But what about those other times, when Auto Exposure won't deliver the shot you intended?

Auto Exposure mode – or its near-equivalent sibling, Program – is like having an instantly responsive photo expert built into your camera. Point and shoot; you're guaranteed a perfectly exposed shot. Unfortunately though, this photo expert is rather blinkered and imagines that you'll always want to shoot in what might be called average conditions: a scene with average lighting conditions and average tones.

Actually, for most photos this is fine; a surprising number of images fall within this configuration of conditions. However as your photo skills and creativity become more extensive you'll begin to come across situations where conditions are not average. At this point, Auto mode is no longer sufficient.

Consider a scene where light, bright tones dominate – a snow scene, for example. Conversely, consider a cosy evening scene featuring darker tones and shadow areas. Shooting either on full Auto Exposure mode will result in a dull, grey snow scene and a bland, over-bright evening scene respectively.

To accurately record scenes like these, then, requires that we identify them and take appropriate remedial action. Identification does come with experience, although there will be obvious situations where you will instinctively know that a compensation needs to be made.

By 'compensation' we're talking about exposure compensation and means adjusting the automatically set exposure to allow in more or less light than the determined setting. Setting an exposure compensation amount is possible on most cameras, either by adjusting a physical dial or by making a selection from the on-screen menu.

Setting a positive exposure compensation (+⅓, + 1, +2 stops for example) allows more light to hit the camera's sensor, thus achieving brighter results when shooting snow scenes. At the same time, setting a negative value will allow less light to reach the sensor, thus resulting in a dimmer scene.

Altering the exposure by 1 stop doubles (+1 stop) or halves (-1 stop) the amount of light entering the lens. Precise compensations are hard to determine, so it's best to shoot with an approximate compensation and then look at the result on the camera's LCD screen. You can adjust the setting more precisely if needed.

Snow scenes: These kind of scenes will confuse cameras' exposure settings so be prepared to dial in around 1 stop overexposure to prevent the crisp white snow becoming slightly murky.

Pro tip

METERING OFF DIFFERENT PARTS OF THE SCENE

To quickly adjust the exposure without altering the exposure compensation amount, take a meter reading from a lighter or darker part of the scene by depressing the shutter halfway then recomposing before fully depressing the shutter. In the straight shot (below) the scene is too bright, and the sky featureless. Metering from the sky ensures that this is properly exposed and the rest of the scene appropriately darker.

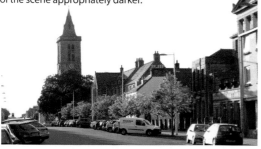

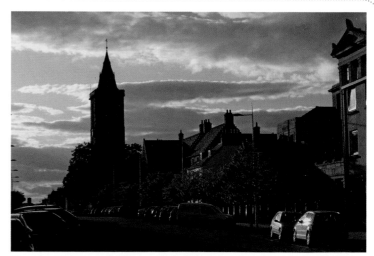

Metering: Metering off different parts of the scene (broadly indicated by the markers) achieves distinctly different results.

12 USE EXPOSURE COMPENSATION TO ENHANCE COLOUR

As well as affecting the tonal and brightness ranges in an image, adjusting the exposure using the exposure compensation control can also affect the saturation – or richness – of colour in your shots.

Back in the days of film-based photography, many photographers would routinely underexpose their photos by ⅓ stop to improve the colour saturation in a scene. It's a technique that can also work in the digital domain. This modest amount of underexposure will prevent bright and saturated colours from becoming slightly – but perceptibly – light.

Experiment for yourself to see where a subtle change can make a visible difference. However, as always when making a change to the exposure compensation control, remember to reset it afterwards. Unless you see real benefit in doing so, don't leave the camera at this setting.

△ Colour saturation: A subtle -⅓ stop exposure compensation can enhance colour saturation.

◁ Colour in the snow: Though snow scenes need to be overexposed to maintain tone, this can also lead to washed-out skies. Reducing the amount of overexposure can retain colour without making whites murky.

13 EXPLOIT YOUR CAMERA'S APERTURE CONTROLS

The prerequisite to a great photo is getting the technical elements right. And that, principally, requires that we get the exposure spot on. To do so we can vary, in different combinations, the exposure time, the lens aperture or the sensitivity of the imaging sensor. Various combinations provide us with the correct exposure, but creatively varying each has a distinctly different result. Let's look here at the effect of varying the aperture.

Telephoto lenses: Depth of field becomes shallower when shooting with telephoto lenses. Watch out, as it's easy to focus on the background rather than the subject.

To some it might be stating the obvious. When you vary the aperture, you vary the amount of light that can get through the lens to the sensor. And in Auto mode the aperture, like the iris of the human eye, can adjust automatically to the ambient light levels. Numerically a wider aperture is denoted by a smaller number, such as f/2.8, while a smaller aperture is denoted by a larger one, for example f/16. Although it's not crucial to the theory, the number is a ratio of the diameter of the lens aperture to the focal length of the lens.

So does changing the aperture merely change the amount of light entering the camera? Ostensibly yes, but changing the aperture also modifies the image. The aperture setting controls the depth of field in the image, or the amount of an image that is in sharp focus. Set a wide aperture and the depth of field will be shallow; focus on an object and very little of the scene in front and behind will also be in focus. Set a small aperture and much more of the scene, perhaps extending from the foreground through to the most distant parts of the scene, will be sharp.

You might think that keeping as much of an image sharp as possible would always be essential, but it's not always the case. Of course, for landscape photos it certainly is. We want foreground detail and everything through to the distant horizon rendered sharply. An aperture of f/16, f/22 or even f/32 would do this. Sometimes, though, we might want to isolate a subject or object from a background – when shooting portraits, for example. A good portrait often comprises a sharp, well-composed study of the subject set against a blurred background, thereby concentrating attention on that subject.

Pro tip

HYPERFOCAL DISTANCES

When you want the maximum depth of field you can be limited. It may not be possible to select the very small aperture that would be sufficient to guarantee a sharp scene. Instead we can focus at a distance called the hyperfocal distance. Roughly speaking, if you want a broad landscape in sharp focus, focus on a point about one third of the way between your intended closest and most distant focus points, then select an aperture of around f/16. Just about everything will be sharp.

Depth of field: The difference between f/2.8 and f/16 can be quite significant. Note how the foreground foliage becomes increasingly blurred at f2.8 (right).

Image noise: Shot at ISO 2000, this shows the characteristics of image noise – a mottled appearance, particularly in the darker parts of the scene.

tip

ISO SENSITIVITY
What is this ISO sensitivity? Nothing mysterious – it's a simple measure of a sensor's sensitivity to light. It's a proportional system: set to ISO 200 a sensor is twice as sensitive as at ISO 100, so will record twice as much light. ISO (International Standards Organisation) is a standard way of measuring comparable levels of sensitivity.

14 MASTER SENSOR SENSITIVITY

Film cameras were restricted to varying only aperture and shutter speed to alter exposure; the film sensitivity was fixed. These days a digital camera also allows you to change the sensitivity of the imaging sensor, thus providing you with further flexibility in setting shutter speeds and aperture.

So, doesn't it make sense to crank up the sensitivity of the sensor to its highest, so you can take advantage of short exposure times (reducing the risk of camera shake when hand-holding the camera) and/or small apertures for the deepest depth of field? If only that were so!

As you might imagine, nothing comes for free and although you can set a moderately high sensitivity, you will reach a practical limit. This depends to a degree on the camera and sensor, but you will reach a point at around ISO 1000 (see ISO sensitivity) where further increases in sensitivity are countered by digital noise, lack of contrast and subdued colours.

This happens because we end up forcing the sensor to produce a good image that is beyond its capabilities. Without going too far into the theory, by amplifying the image information from the sensor we are also amplifying electronic noise in the sensor. This naturally then leads to poor image rendition.

15 GET THE TIMING RIGHT

Look at a great action photo and you'll appreciate that if the image had been shot a fraction of a second before or after, it would have dramatically reduced the image's impact. For many shots timing is critical and you need to develop an eye – and a mindset – for getting the timing spot on.

I've been told, when people look at a powerful action photo I've shot, that I was lucky to get the timing right. To a point, luck does play a part in shooting at a critical and precise moment, but skill and experience play their part, too.

Indeed, several factors come into play in getting the shot at the key moment. Familiarity with your subjects helps: knowing how your subjects move and the critical part of their action. You also need to be very familiar with your camera, knowing exactly when to press the shutter release. Almost all cameras have a lag time between pressing the shutter and the photo being taken. In some – the more professional and enthusiast cameras – that lag is negligible; in others it's more significant.

You need to be able to assess how far in advance of the exposure you need to press the shutter, and only practice can develop this awareness. However there is a cheat: using the camera's Burst or Continuous mode. If you're not familiar with them, these modes let you shoot a burst of images in quick succession. You can then choose the best image from the sequence when you review them. Yes, it's a cheat, but it's also a type of cheat used by many pros!

WATCH OUT!

Have you ever shot what seems to be a brilliant portrait-style photo only to discover when you review the shot later that your subject, or one of your subjects, has blinked? Unfortunately this happens all too often and immediately a potentially great shot is ruined. Lower the risk by firing off two or three shots in quick succession and repeat the process a couple of times. If all else fails you can do some deft work in your digital darkroom, using the best – non-blinking – expression from one image to clone over another.

Pro tip

ASSESSING SHUTTER LAG
If your camera is prone to noticeable shutter lag, here's a quick way to suss out the amount and to learn how to compensate. Find a clock with a second hand, best of all a sweeping second hand. Press the shutter release when the second hand is on 12 o'clock. Look at the resulting photo and see how far the hand has moved on. Now compensate for that amount ahead of the hand reaching 12 o'clock. With some practice – and it can be frustrating – you can time your exposures precisely to hit that point.

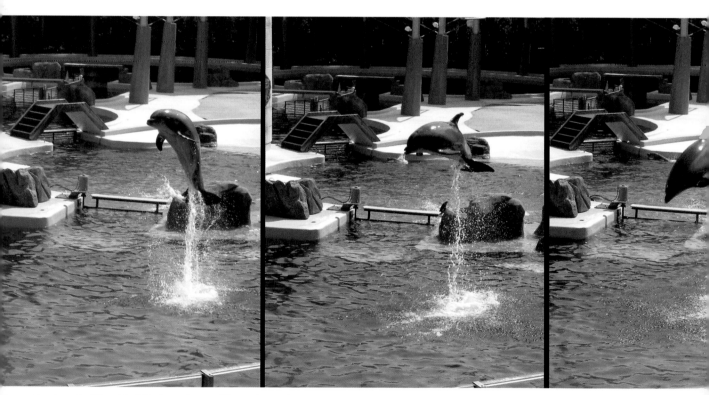

Burst mode: When it's difficult – or impossible – to know the precise moment that is going to deliver the best shot, use Burst or Continuous mode to grab a series of successive views then choose the best later.

16 CAPTURE THE DECISIVE MOMENT

Acclaimed reportage photographer Henri Cartier Bresson first popularized the term 'decisive moment'. The term describes the skill of capturing the moment, that almost instantaneous time when everything in your photograph is perfect. Knowing that precise moment for a perfect shot is what can make or break a photo – or make or break a photographic reputation.

Let's examine a real world example: here's a shot where timing was crucial, but composition, too, was significant. The scene was in London's Olympic Park, where two children were standing on a hilltop by the Agitos logo, looking down into the heart of the venue.

Set against a bright night sky, the children and the Agitos logo together made a great composition. Then, a moment later, a firework display started. A great composition suddenly became something much more as the children were suddenly silhouetted by the expansive firework display.

In normal circumstances, when time was not a factor, I would probably meter from the fireworks, apply a modest exposure compensation (say -1 stop), and try some bracketed exposures. In that time I would have probably lost the moment – the fireworks might have stopped or, more likely, the children moved.

Instead, I had preconfigured the camera – in this case, at f/4, $\frac{1}{25}$ second and ISO 200 – which proved sufficient to record an appropriately underexposed night scene. So, did luck play a part? I'd have to say yes. And it always will, but as your skills develop you will rely less and less on the luck element.

▷ **The difference a second makes: The first shot (top) was a silhouette against a bright sky, then a second later the firework display starts. The scene is transformed and shows how a fast response can be rewarded.**

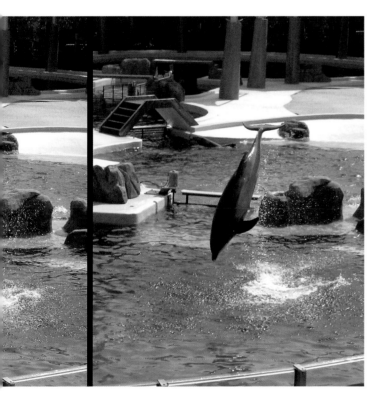

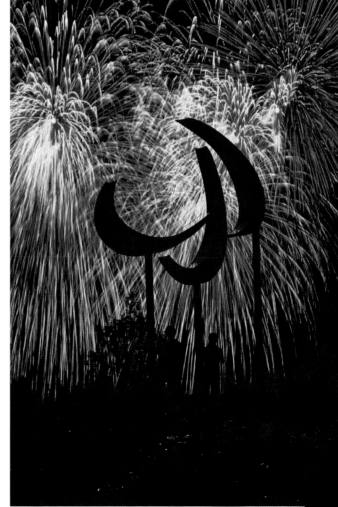

17 UNDERSTAND PROBLEMS

People, it is said, learn more quickly by making mistakes. This may not always be true but it has to be admitted that even the most accomplished of photographers make errors more frequently than they may care to admit. Compositional errors, technical errors; here we'll look at those that frequently occur and how to resolve them.

Unlike for traditional film photographers, where an error could not be spotted until the film was processed, at least today we have a chance to review our shots. However, what if they don't look right on your camera's LCD? Here are some reasons why.

Pro tip

BRACKET YOUR EXPOSURES
When the lighting conditions make it difficult to get the exposure right, try bracketing your exposures. This means shooting three or more shots of the same scene but increasing and decreasing either the aperture or exposure time between shooting each.

Bracketing: A range of bracketed exposures makes it easier to choose the correct exposure from a potentially problematic shoot.

UNDEREXPOSURE: PHOTOS ARE TOO DARK
Why?
- Exposure compensation is set to underexposure.
- A bright object – the sun for example – is in the metering area and skewing the overall exposure.

Fix
- Check the exposure compensation dial and adjust as required.
- Take a meter reading that excludes any bright light sources.
- Switch to spot metering (if your camera permits) and take a reading from an averagely lit part of the scene.
- In Manual mode, select a slower shutter speed while keeping the aperture constant, or select a wider aperture while keeping the shutter speed constant.

OVEREXPOSURE: PHOTOS ARE TOO LIGHT
Why?
- Exposure compensation is set to overexposure (+1, +2).
- There are large areas of dark in the scene, influencing the overall exposure.

Fix
- Check the exposure compensation dial and adjust as required.
- Take a meter reading that excludes darker parts of the scene.
- Take a spot meter reading (if your camera permits) from an averagely lit part of the scene.
- In Manual mode, select a higher shutter speed while keeping the aperture constant, or select a smaller aperture while keeping the shutter speed constant.

PARTS OF YOUR SHOTS ARE TOO BRIGHT, PARTS ARE TOO DARK
Why?
- The contrast in the scene is too high for your camera to accommodate all brightness levels.

Fix
- Underexpose slightly (say -1 stop). This will provide better exposure of the highlights, then you can correct the darker shadow areas later (see Bracket your exposures).

PHOTOS LOOK GRAINY OR NOISY
Why?
- The ISO sensitivity is set too high.

Fix
- Set a lower ISO sensitivity. Use ISO 100 to 200 in bright conditions and only use high settings of ISO 1250 or more when conditions give you no choice.

PHOTOS ARE NOT PIN SHARP
Why?
- The shutter speed is too low and you've unintentionally allowed a small amount of camera shake.
- Your camera hasn't focused precisely on your subject.
- The lens setting is not at its optimum.

Fix
- Choose a higher shutter speed and increase the ISO sensitivity or aperture to compensate – or use a tripod.
- Check the subject hasn't moved since you focused and that the camera has focused precisely on the subject.
- Some lenses – particularly wide range zoom lenses – don't give pin sharp results with some aperture settings at high zoom settings. Try and select a smaller aperture setting instead.

YOUR BACKGROUND IS NOT SUFFICIENTLY BLURRED IN A PORTRAIT SHOT
Why?
- You've selected too small an aperture so the depth of field is too shallow.
- The subject is too close to the background.

Fix
- Select the widest possible aperture.
- Stand the subject further in front of the background.
- Stand further back and choose a telephoto lens setting, which will produce a shallower depth of field.

YOU BACKGROUND IS BLURRED – BUT SO IS PART OF YOUR SUBJECT
Why?
- The depth of field is not sufficiently deep to keep all the subject in focus.

Fix
- Select a slightly smaller aperture (say +1 stop) and check the focus range using the depth of field preview.

18 DELIBERATELY GET THINGS WRONG

Well, 'wrong' may not be the right word, but for some images, underexposure or overexposure provides a better result than exposing to the conventional, accurate meter reading.

Images that feature large areas of bright tones need to be overexposed to achieve accurate rendition. Consider dialling in an extra stop of exposure compensation – or even more. Images that are dark, or that feature a predominance of dark tones, should command a stop or two of underexposure. Take a look at the images here and see what a difference the exposure adjustment can make.

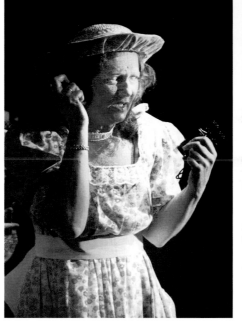 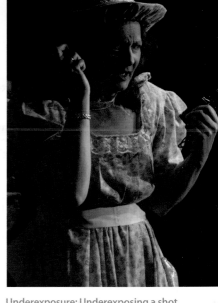

Underexposure: Underexposing a shot with dark areas gives a more natural result, as in the case of this actress set against a very dark background.

Overexposure: Overexposing bright scenes – such as here with extensive white marble – ensures that they are correctly exposed, rather than these brighter elements appearing murky.

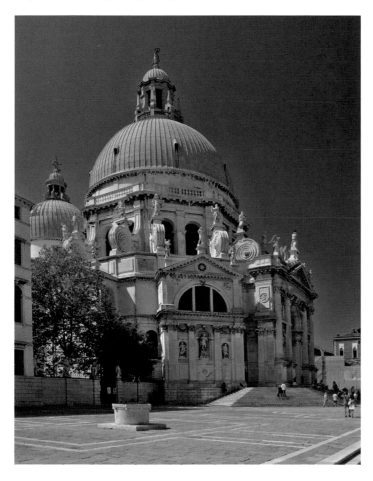 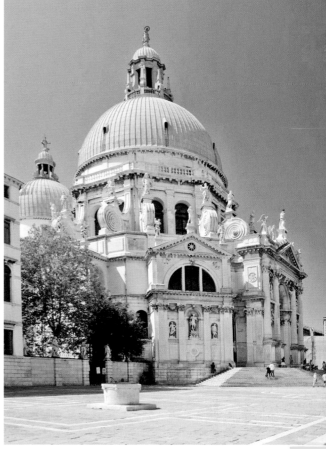

19 MASTER THE TECHNIQUE: MANIPULATING EXPOSURE

Generally, following advice on exposure will help you shoot perfectly exposed shots. However sometimes situations will arise that defy the simple wisdom of exposure control, situations where the light is just too extreme for the sensor to accommodate. Under such conditions – which you'll come across surprisingly often – we have to carefully assess our exposure so we can eek out every tiny morsel of image information, using this to create a brilliant, well exposed image.

Let's look at a real world example. This view of Steep Hill in Lincoln is one of those that frequently appear in the tourist press. But it's a view that, especially when the sun is out, is remarkably problematic to shoot. Bright skies and a deep, narrow street view conspire together to render any normal exposure incorrect. The sky ends up being over bright and the street itself lacking in character and bland.

In fact, the sky in this standard shot is so bright that not only does it appear featureless, there is no image information recorded for it at all. This means that there is just no way that we can correct or rescue this part of the image. No matter what digital manipulations we apply, we will always be left with this blank, featureless sky. It will dominate the shot and provide, in imaging terms, a disastrous distraction.

What, then, if we reduce the exposure? Decrease the exposure time from, say, 1/60 second to 1/25 second or even 1/250 second instead. Or close down the aperture from f/8 to f/11 or f/16 – although for a landscape shot like this, depth of field is paramount and the aperture should be as small as possible. Or take a meter reading from the sky, pointing the camera towards the sky and locking the exposure by partly depressing the shutter release?

Any of these methods should deliver a correctly exposed sky, but this comes at a price in the form of a deeply shadowed foreground. So, for the sake of getting a correctly exposed sky, have we introduced an equally disastrous change to the darker parts of the scene? Not quite. Exposing for the brighter areas may render the less bright areas darker, but those areas still contain picture information. Now we just need to bring this out so that our image not only looks evenly exposed, but also looks better than those professionally shot tourist brochure images.

A quick way to review the extent of the image information largely concealed in the shadows is to apply the Shadow/Highlight

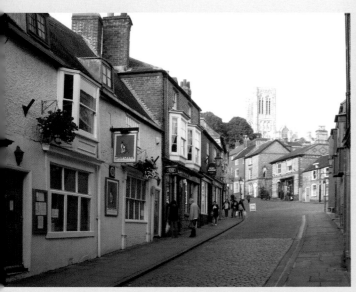

Steep Hill: Shooting using a standard exposure setting results in a scene where the exposure is essentially incorrect throughout.

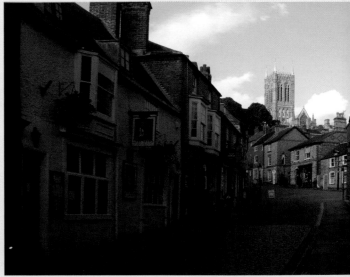

Metering from the sky: Taking a meter reading from the bright background and sky gives a correct exposure for those areas but at the expense of the foreground.

command in an image editing application. It will reveal the colour and tone information, even if to apply it would result in a rather unnatural image. You can use this tool – with settings of no more than 10% – to start brightening the shadow areas, but be careful not to apply anything more.

Next steps? We need to lighten those shadows but in a controlled way. The Shadow/Highlight tool can be a little blunt in the way it applies its lightening effects, basically delivering them on the principle that the darker an area was, the more lightening was needed – not a real world situation. Instead we need to be more considered and use the digital darkroom tool, Dodge. We'll have more to say about this later, when we'll be using it along with its stable mate the Burn tool to produce moody landscapes (see Enhance tone with digital manipulation).

For the moment we'll use it to lighten the brighter parts of the shadow areas. We can do this by selecting an amount of dodging and indicating whether it should be applied to the highlights, mid-tones or shadows. We'll start with highlights by selecting a dodging brush size and gently brightening the lighter parts of the scene. After this we'll do the same – but to a lesser extent – to the mid-tones and then to the shadows.

Finally, we'll give the image some punch by increasing the colour saturation. Again this should be done gently using the Saturation tool. Those areas we've lightened need a little more application as the shadow areas often show less colour saturation, but the whole image gets a modest saturation boost, too. It's a trick that publishers of travel books and magazines have long used, so why not follow suit?

There's no doubt that the result pays for the modest effort involved. The initial, disappointing shot has now been replaced by one that is not as the camera would normally see, but is closer to how our eyes see, as they automatically adjust for brightness variations.

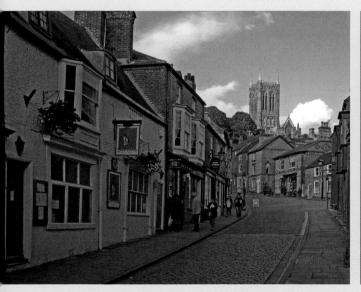

Details revealed: The potent Shadow/Highlight command will reveal the colour and detail in the shadows, but needs to be used with subtlety to avoid a very unnatural, flat result like this.

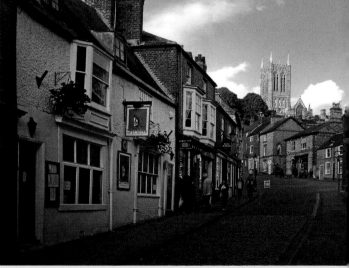

Final image: Here's the final result, with the detail squeezed from the shadows and the colour given a bit of a boost.

CHAPTER 2: CAPTURING THE PERFECT PORTRAIT

Some time ago I spent a day with a well-known landscape photographer. He was meticulous in the way he crafted his images, and would wait what seemed an interminable time to get the look of his scene just right. Whilst he accepted the vagaries of the weather, he had little patience with people wandering into his shots. 'They ruin my shots,' he said, 'If I wanted to photograph people I'd be a portrait photographer.'

There is a belief, even amongst some professional photographers, that shooting portraits is difficult. It is not; it merely requires some additional skills over and above those that you might use for other subjects. And those skills are not just photographic: for example, it's good to have – or develop – great interpersonal skills. You'll need to strike up a rapport with your portrait subjects so they feel relaxed and at ease, allowing their true character to shine through in the portraits you shoot of them.

In terms of technique we'll be calling into the frame – somewhat literally – some skills we've discussed already. For example, our knowledge of lenses and depth of field so that we can control the degree of separation between our subjects and their setting. Also composition, to ensure that the eye is led to the appropriate part of the portrait and that the scene is appropriately conceived to best show the subject and, where appropriate, their character.

We will also need to remain very mindful of the lighting. There's no reason why portraits should not be taken using natural light – indeed, there are many good reasons to use this form of illumination – but we also need to be aware of the ways we can enhance, modify or even supersede ambient lighting if it will give a more pleasing result. With just a little practice you too will realize that portrait photography is not something to be avoided but rather something to be embraced. And if you have aspirations for making money from your photography, nothing sells better than a great portrait!

20 UNDERSTAND BASIC PORTRAIT GUIDELINES

The term 'portrait photography' is something of a broad phrase that describes a wide range of styles and approaches, from the formal to the more relaxed and casual. Whatever your style or intent all portraits can benefit from following, even if just in spirit, some simple guidelines.

I use the description 'guidelines' because to call them rules would be too proscribed. Don't be concerned if the situation in which you are shooting precludes you from following them all, or requires you to modify them. A great portrait is a great portrait – whether or not it conforms to accepted rules! My basic guidelines are as follows:

- **The eyes have it:** Focus, that is. It can be difficult to get the whole face in focus, so always ensure that you focus on the eyes or, if the subject is at an angle, the closer eye. When you view a portrait you are always drawn straight to the eyes so get this focus wrong and it can ruin the shot.
- **Shoot at eye level:** For a good neutral portrait shoot at your – or your subject's – eye level. Bear this in mind particularly when shooting children (at birthday parties for example) as you'll need to be right down in the action at their eye level rather than appearing somewhat detached, shooting from a higher position. However don't be afraid to point up or down should you want to introduce a little drama into your shots.
- **Shoot at 45 degrees:** Some angles – and approaches – work better than others. Face on and side view shots have their uses but generally your subjects will look their best when shot at intermediate angles.
- **Check the background:** Emphasize the subject of your portrait by ensuring that the background of the shot doesn't compete for attention in the photo. Avoid cluttered backgrounds or lots of bright colours. You can set a wide aperture to ensure that, even if the background is not ideal, it will be rendered as a blur.
- **Shoot quickly, shoot several:** If you're posing your subjects, their expressions can look forced if you make them stay waiting for you to shoot them. Shoot fast, and take several shots in a row. Often subjects relax a little after they hear the shutter fire a few times and have a more natural look.
- **Check for lighting and shadows:** Cameras can exaggerate shadow details and if the sun is high in the sky it can create heavy shadows, especially around the eyes. Avoid shooting with the sun or light source behind your subject unless you take action to even out the lighting.
- **Use the Portrait Scene mode for quick shots:** Set your camera to the Portrait Scene mode and it will configure your camera to shoot the best possible portrait shots if you've no time to set the camera manually.

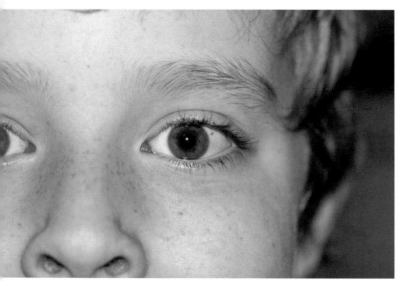

Face: A portrait need not always be full face; a tight crop can be very powerful, as shown here.

Focus: Always focus on the eyes, even if the eyes themselves are not clearly visible, as the viewer's attention is always drawn to the eye region first.

Pro tip

LIGHTEN THOSE SHADOWS
Turn on the camera's fill-in flash to lighten the inevitable shadows created when shooting in bright daylight or when facing into the sun. Pro photographers even carry reflectors to reflect light back into the shadow areas.

Fill-in flash: This prevents deep shadows showing and is almost essential in bright lighting conditions or, as here, with strong backlight.

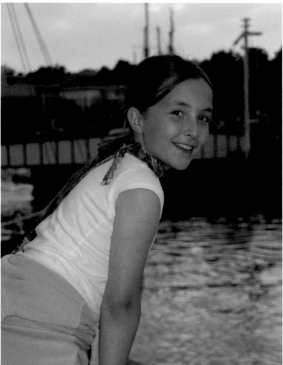

Low angle: Shooting children from below their normal eye line can help make them appear more confident.

Composition: Conventions regarding composition – here the rule of thirds – are just as valid for portraiture as for any other subject matter.

Character: Shooting people at work can help emphasize their character and produces a more natural result (see Shoot portraits of people at work).

tip

PORTRAIT LENSES

If you fall in love with portrait photography and you have a dSLR, you could invest in a portrait lens. These have a short telephoto focal length and a wide aperture, making them ideal for sharp shooting your subject while keeping the background suitably blurred.

21 TRY FLASH FOR OUTDOOR PORTRAITS

When shooting portraits outdoors you can strike lucky and find that the lighting is perfect – perfect for showing off your subject, if you will forgive the phrase, in the best light. In real world situations the light is rarely so accommodating, but we can manipulate it to get better results. Let's look at how we can do that, first using flash.

A simple way to improve the lighting outdoors is to use flash. This might sound counterintuitive: we use flash when the ambient light is too dim for a successful shot or when we're indoors, don't we? Well, have a think about it. The problem with portraits shot outdoors, particularly those taken in strong sunlight, is shadows, yet shadow areas are nothing more than parts of the scene that are poorly lit. So why not use flash to lighten them?

In fact, we need to use carefully controlled flash lighting, where the light level from the flash is balanced with the lighting in the rest of the scene – enough to brighten darker areas but without making the use of flash obvious. This is called fill-in flash (or fill flash) and the good news is that many cameras or camera and flashgun combinations have a setting that calculates and applies this feature automatically.

Pro tip

MANUAL FILL FLASH
Like Auto Exposure, the camera's attempt at fill-in flash may sometimes get it wrong. Luckily cameras (or flashguns) let you manually fine-tune the amount of flashlight. Set the camera and flash to their normal mode and then set 1 stop of underexposure on the flash using the flash exposure compensation.

Fill-in flash: A modest burst of flash can brighten shadows and create a more even illumination.

22 CREATE FLATTERING LIGHTING WITH REFLECTORS

Often when shooting portraits outdoors (or indoors for that matter) there's plenty of light around; it just happens to be in the wrong part of the scene. Using photographic reflectors such as the TriGrip from reflector supremo Lastolite can help to direct light around the subject to create a more even and flattering lighting effect.

On a bright, sunny day you have the potential to capture some brilliant outdoor portraits. But, strong, bright lighting will produce harsh shadows; ones that can make bright eyes look dull and sunken and can emphasize the neck. The results, even with the most photogenic of subjects, is rarely – if ever – flattering.

Reflectors like the TriGrip provide a large reflective area that is sufficient to reflect sunlight back into the shadows.

Furthermore, this type of reflector is available in a range of colours, such as white, silver, soft gold and gold. These can modify the light reflected back to add warmth, generally appreciated in portraits.

Although it's tricky to do this on your own (an assistant can come in useful here) using a second, diffusing panel to soften the direct light falling on the subject can give an even more pleasing result, as the illustrations here show.

tip

IMPROVISED REFLECTORS
If you find yourself with the perfect portrait opportunity but you've left your reflector at home – or you've never invested in one – you can improvise with a sheet of card (or a flattened box) and some aluminium foil. Use the less reflective side of the foil and wrap it around the piece of card; this won't be perfect but it will deliver a much better result than a straight shot without it. Failing that, a sheet of white card or even stiff paper can help lift shadows around the neck and eyes if positioned close but out of shot.

Using a reflector: This wedding shot (left) would disappoint the bride and, no doubt, the whole family as a bright day and overhead sun has produced intense shadows, particularly over the face. Angling a reflector to reflect some of the bright sunlight back into the shadows gives a much more even – and pleasing – result. Although tripod-mounted here, reflectors like this (which fold away) are easily hand held.

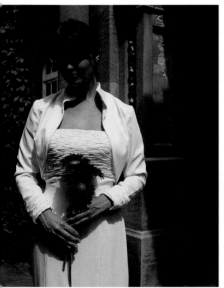

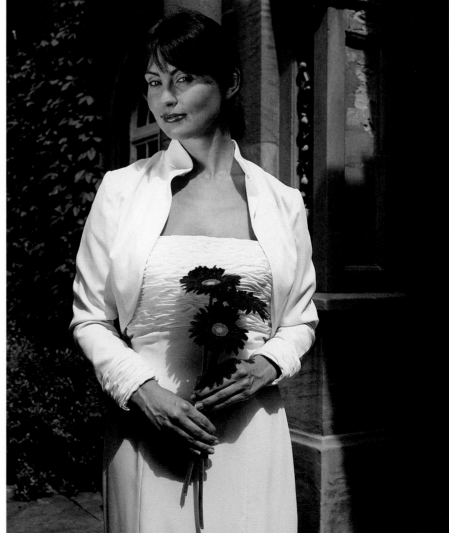

23 BECOME ADEPT AT CHILD PORTRAITS

Rewarding and frustrating – photographing children is both. Rewarding because children make such fantastic subjects, and frustrating because that's the way children are! To become adept at child photography you need the skills of both a portrait and action/sports photographer.

Nice, but…: Too often portraits of children are stiff and portray little about the child's character. We can do better.

Shooting children, then, needs a modified skillset compared to that of a conventional portrait photographer. Lets take a look at what you need to get some great, characterful shots:

- **Shoot plenty:** Children move fast and their expressions change from second to second; they will also be conscious of the camera. A series of shots with the camera set to Action/Sports mode rather than Portrait can catch them off guard, being themselves.
- **Shoot at the child's level:** Shooting downwards at children makes them appear diminutive and vulnerable. Instead shoot from their eye level, or even below if you want to make them appear more confident.
- **Avoid stiff portraits:** Leave these for school photos. Children tend to be active rather than staid, so reflect this in shots.
- **Use props:** Shooting children, especially younger ones, with props such as their favourite toys and in familiar settings can take their mind off you and your camera. A child riding a bike, playing a game or jumping on a trampoline can all produce great natural shots.
- **Smile, please:** Happy children produce great shots, so encourage them to smile naturally whenever you can.
- **Use fill-in flash:** Although the scene may not demand it, using fill-in flash can not only lead to a brighter shot (that will always flatter a younger subject) but also lead to great 'catchlights' in the subject's eyes. These are bright white spots (reflections of the flashlight) that will make their young eyes sparkle.

Ideal portrait: Adopting a position just below the child's eye line, using a simple background and a touch of fill-in flash, produces a much more effective portrait.

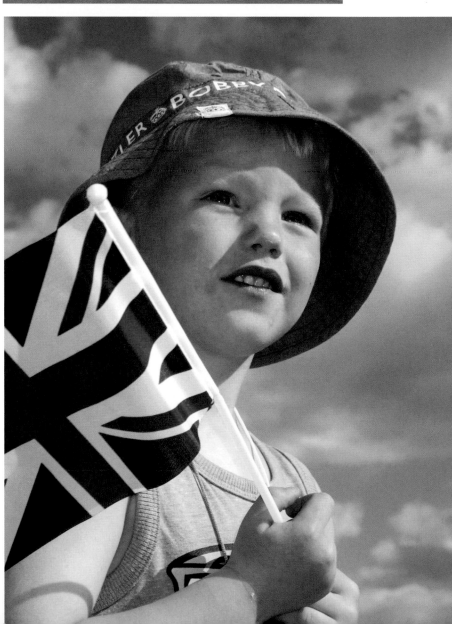

WATCH OUT!

Shooting children can be frenetic but is always fun. There are just a couple of things to be mindful of. First of all, sensitivity; it's unfortunate to say that photographing children can raise unfair concerns, so stick to shooting your own or those of friends and family – sad, but true. Second, you can get some great shots of children eating ice creams, for example, but as a rule children eating won't make for appealing images, so use your discretion – or a face cloth!

24 SHOOT GREAT PET PHOTOS

Pets, like children, make great photo subjects but are, if anything, more troublesome to shoot. Pretty much the same advice applies: if patience is a virtue when it comes to child photography, it is even more so when it comes to pets.

Here's the advice we've given for child photography slanted more towards dealing with pets:

- **Get down to their level:** We normally view pets from our level; shooting from theirs provides more intriguing and powerful photos.
- **Shoot them doing what comes naturally:** It may be bounding across a field, sitting provocatively in a favoured armchair or sitting at a window waiting for their master's or mistress' return. Such poses – or action shots – tend to better convey the pet's character.
- **Use natural light:** Pets can be timid when it comes to flash, particularly if it's close up. Worse, flash can cause red-eye in cats and dogs. Actually, in these cases it's green eye but it's just as unflattering.

- **Hold the pet:** Some pets just won't sit still no matter what you try. Have someone hold the pet and concentrate on a face or head and shoulder type shot. For smaller pets – hamsters and the like – in-hand shots can be surprisingly effective and help to give a sense of scale.
- **Use treats and props:** You might be surprised at how a favourite toy or prop can distract your pet sufficiently in order to take a successful off-guard photo.
- **Call him or her by name:** Calling the pet's name can bring him or her to attention. Get ready for the shot by pre-focusing before calling out.

Get down: Shooting from a pet's eye level better conveys their world and their view of the world. Shots can work with and without eye contact, just as in any other form of portrait photography.

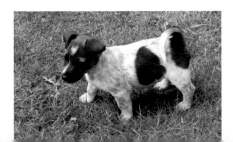

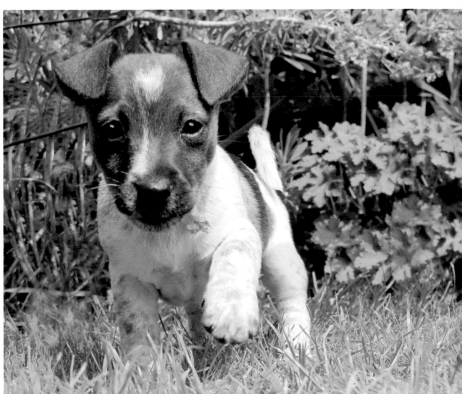

25 USE A CAMERA FILTER TO CREATE A SOFT, ROMANTIC PORTRAIT

Give your portraits a soft, feminine touch using a soft focus effect. This can be easily achieved in camera and doesn't need much in the way of special equipment. In fact, it can be done with a simple soft focus filter, which is widely available.

The soft focus effect, if you look closely, is not one of blurring the image. You will see that a soft focused image is actually as sharp as a conventional portrait might be, but rather is overlaid with a softer, more diffuse glow. Largely clear, the soft focus filter also features regions that have diffusing patterns or raised areas, rather like water droplets. A sharp, conventional image is produced through the clear areas while an overall diffused glow is formed through the patterned ones.

Altering the aperture can vary the amount of softness produced in your shot. Set the aperture wide at f/2 or f/2.8 for more obvious softening than shooting at f/5.6 or f/8; anything less is a no-no as your images

will start showing the structure of the filter. A slight overexposure (up to 1 stop) can also help to achieve a bright, delicate look.

Soft focus: Applying a soft focus effect can bring a dream-like quality to a portrait photo.

Pro tip

WARMING UP PORTRAITS
Romantic portraits can look even better if given a subtle warm, rosy glow. Use the Photo Filter option in your image editing application to apply an overall warm amber or pale rose tint. Keep the amount low though, at about 25%, to avoid the colour becoming too bold.

Warming up: A modest amount of red/orange digital filtration was applied to this portrait to provide it with an increased amount of warmth.

26 USE SOFTWARE TO CREATE A SOFT, ROMANTIC PORTRAIT

Alternatively, you can use your image manipulation software to add controllable soft focus effects to your portraits.

To use this method shoot your portrait without any kind of soft focus filter attached to your camera. The advantage is that you can focus on getting the best possible portrait, without having to worry about the amount of softening applied. It's when you download your image to the computer that you can work on creating that dreamy look.

Open your image in your favourite image editing application:

1. Create a duplicate layer of the image.
2. In this duplicate layer, apply a Gaussian Blur. The amount of blurring will depend on the size of your image, but a setting of between 8 and 20 is a good starting point. The great thing about this method is if it doesn't look good, you can step backwards and alter the values.
3. Reduce the opacity of the duplicate layer so that the original, sharp image appears through the layer; an opacity of 45% to 65% will give good results.
4. Finally, review your image and alter the settings if you think this will deliver a better result: there's no right and wrong!

Pro tip

A BRIGHTER, DREAMIER EFFECT
Here's how to make your portrait even more romantic. When you've applied your Gaussian Blur to the layer, make a copy of that layer. Rather than changing the opacity, change the Layer Blend mode from Normal to Lighten or, for a more dramatic effect, Screen.

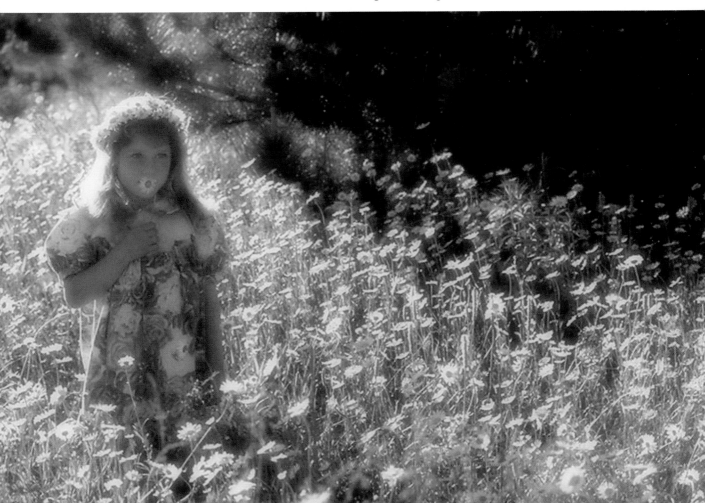

Blend modes: Make a copy of the Gaussian Blur layer and then apply the Screen Blend mode for an even brighter, almost ethereal portrait. Compare this image to the originals (see Use a camera filter to create a soft, romantic portrait).

27 SHOOT PORTRAITS OF PEOPLE AT WORK

When we shoot people in their working environment – whatever that may be – we have a greater chance of capturing their true character. Their workplace not only provides a great foil to a portrait, but it also adds interest to the scene.

Artist: Equal prominence is given to the subject and the object of his labours, thus producing a well-balanced image that leaves no questions about the scene unanswered.

When we shoot people at work we can adopt a candid approach, where we record people going about their normal activities, or we can use the workplace setting for a more obviously posed portrait. Whichever approach you use, it is important to achieve a good balance between the workplace and the subject, or subjects.

It's also important to capture the atmosphere of the workplace. Craft workers often use specialized lighting or work in conditions that might be considered dim. Rather than using flash, which would tend to destroy any atmosphere, try increasing the camera's ISO sensitivity so you can shoot at an appropriate shutter speed, and underexpose if you want to preserve the dark tones and mood.

When we talked about conventional portraits we mentioned the importance of people skills in building a rapport with the subjects of our portraits. This can be even more important in the case of workplace photography. Often the people you shoot will be less inclined towards having their picture taken, so putting them at ease with you – and your camera – is crucial.

Sometimes, though, you'll meet someone who is not so camera shy. Then you can adopt a different approach, where eye contact with the camera is not to be frowned upon but rather celebrated. Shoot these subjects smiling or laughing as they work, or even presenting their finished products – whether these are an electronic circuit board, a clay pot or even a cupcake – to the camera!

Engineer: OK, so this is a hobby rather than work, nevertheless the principle remains the same. More reportage than portraiture, in these instances you are capturing a scene of interaction rather than an obvious portrait.

Artisan: A skilled worker will be applying him- or herself to creating something of beauty and will often be oblivious to any camera, as was the case with this Burano glassworker, captured during two different stages of his work.

Happy in your work: Some people enjoy the work they do, so don't be afraid to show a genuine sense of fun in your photos. People in more public facing roles tend to be less reserved when it comes to being photographed and will happily play to the camera.

Pro tip

SHOOTING BLIND
Some people may find being photographed at work intrusive, or they may act in a more self-conscious way when cameras are around. In these cases you can achieve some great results by shooting blind. Leave the camera on a table, pointed casually at your subject, or hold it at waist height and shoot surreptitiously in the direction of your subject. You won't produce a brilliant shot every time, but at least with a digital camera you can quickly check your results and reshoot if necessary. If your camera has a fold-out screen then you can increase your chances of success somewhat, viewing the scene from the side or even towards the front without alerting your subject's position.

28 SHOOT CHARACTER PORTRAITS

Shooting portraits should be more than making simple records of people's faces, which is something that should be left for passport and ID card photos. The portrait should catch the expressions and the 'look' that makes a face become a person – it's all about shooting character.

The term 'character portrait' was originally applied to portraits of people that emphasized or caught the essence of their character. Think of those famous portraits of 1950s movie stars that make us immediately link the star with their most celebrated character roles.

You don't have to travel far to shoot character portraits; people with, if we can use the phrase in a photographic sense, 'interesting' faces are everywhere. Consider the grizzled face of an unhappy toddler, the moody stare of a teenager, or the profound concentration of a musician. The skill in character portrait photography comes from being able to shoot these subjects when their expressions are at their most natural.

So, what distinguishes a character portrait from a simple portrait? In a simple portrait we generally try to show the subject at their flattering best. For the character portrait we can still be flattering, but we tend to go further and reveal something about the charm – good or bad – of the subject, too. We can follow the same principles as those for any other portrait, although we will put a slightly different slant on some:

Pro tip

APPLY A CLOSE CROP
Unless the character of your subject is intrinsically linked to their physique or demeanour, you can often enhance your portrait with a tight crop, thus concentrating the viewer's attention on the face.

Monochrome: Black and white or monochrome character portraits are popular as they can make a character portrait more intense, concentrating on tones and contrast rather than colour.

- **Perspective:** Manipulate perspective to predefine character. For example, shoot from a high angle to imply subservience and insignificance; alternatively, adopt a low position to imply dominance and superiority. Shooting from eye level is a good way to achieve strong, personal eye contact.
- **Eye contact:** This can provide a strong connection to the subject or can be unsettling – depending on the subject. There is no need to always establish eye contact: a subject looking above the camera into the distance implies a dreamer, while a subject looking down implies introversion.
- **Composition:** You don't always have to follow the formal rules of composition to shoot a winning portrait; breaking the rules can often achieve a dramatic effect.
- **Lighting:** We've looked at how best to light a subject but you can get powerful results by bucking those rules. For example, backlighting your subject is great for a threatening pose.
- **Be original:** Not every portrait needs to have a human or animal subject. Why not try experimenting with statues?
- **Bold or candid:** A clear connection between the subject and photographer is a good way to capture an intense expression or personality, but don't underestimate the natural results you can get from candid shots.

Props: Presenting the viewer with visual clues in the form of props will enhance their understanding of the sitter.

- **Romantic or gritty:** A soft focus effect is great for suggesting a romantic or soft character, but is not something that could be applied to a more masculine or hard character. For these subjects, a gritty portrait – using a high ISO setting, or adding a Grain effect in post processing – is more appropriate.

29 EMPLOY LOW-KEY PORTRAITURE

Another powerful way to add mood, drama and character to your portraits – particularly for male subjects – is to employ the low-key technique. By controlling the tones in your image with careful underexposure, you will be able to create remarkably powerful portraits.

This technique – essentially one of exposure control – puts the emphasis on the darker tones within an image.

Using hard lighting, dark backgrounds and careful control of the shadow areas, low-key portraits substantially feature middle to dark tones with small, brightly lit areas. These provide a bold counterpoint to the shadows that would otherwise have dominated the scene.

It's important when shooting low-key portraits to keep the shadows under control. After composing your subject, set the exposure compensation to -2 stops to get the (approximate) mix of dark tones, but then check the shot. Experiment with different amounts of exposure compensation until you get a bold, dark and brooding result.

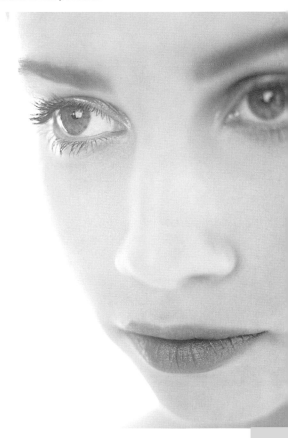

Low-key: Letting darker tones dominate the scene – with just modest areas of lighter tone – produces a dark, brooding portrait.

High-key: The converse of low-key is high-key, where the light tones predominate. Like soft focus it is good for – though not exclusive to – romantic, feminine portraits.

30 PORTRAIT PHOTOGRAPHY

A successful portrait is a mix of spot-on exposure, perfect lighting and precise – or imaginative – composition. As we've seen, a portrait need not be of a person or even a pet. A statue or even something even more obtuse – such as a hot air balloon – can be the perfect foil for developing your portrait skills.

ESSENTIALS
- Unless you're doing something novel, portraits need to be pin sharp when shot. Later we may decide to apply a soft focus effect or even retouch (conceal) any marks or blemishes.
- Match the look of the portrait to the subject. Create a bright, lively portrait for an extrovert character, whereas a dark, low-key portrait will be more suitable for a more thoughtful character.

TAKE CARE!
- **Keep the eyes sharp:** If the depth of field prevents the rest of the face being in sharp focus, the eyes of a portrait should always be sharp. If a subject has adopted an oblique pose, the eye closest to the camera should be in focus even if it is not possible to keep both well defined.

EXPOSURE MODES
- **Portrait mode:** The Portrait Scene mode features on many cameras, from simple

Portraits: Perfect exposure, composition and lighting will reward you with a delightful result.

Removing blemishes: The Rubber Stamp/ Clone tool is ideal for removing small spots, wrinkles and other blemishes. However don't overuse; wrinkles and marks can help to define a person's character.

compacts through to digital SLRs. This is ideal for quickly configuring your camera with a wide aperture and modest telephoto lens setting, particularly if you need to shoot a great portrait in a hurry or if your camera does not boast an aperture priority exposure mode.

- **Aperture Priority mode:** As the aperture of the lens defines the depth of field – crucial in many portrait shots – switch your camera to this mode when preparing to shoot a portrait. Set a wide aperture – from f/2 to f/5.6 – depending on what your lens can offer and the depth of field required.

IN YOUR KIT BAG

- **A firm support:** A tripod or equivalent.
- **Reflectors:** Perfect for filling in shadow areas.
- **Flash:** An external flash is ideal for brightening shadows either with, or instead of, a reflector. Set the flash, either on the on-board unit or a separate flashgun, to Fill mode.

GOOD TO GREAT TIPS

- **Choose your lens carefully:** For best results in conventional portraits, use a modest telephoto setting – 75mm to 100mm in 35mm equivalent – to avoid distortions. Alternatively, shoot close up with a wide-angle lens to achieve a dramatic warped effect.
- **Beware of blinking:** I don't know what it is but people seem to blink more when being photographed – or so it seems. Take plenty of shots, with some in close succession, to avoid the risk of your best-posed shots being ruined as the subject blinks.
- **Explore different compositions:** A conventional portrait format shot isn't necessarily the best one for your subject. Landscape format shots can be equally successful and I've even seen panoramic formats used for unusual – but effective – portraits.

Experiment: Use unusual lighting or compositions for novel but fun portraits.

Pro tip

SPOT REMOVER

Some subjects can be a little sensitive when they look at the results of a photo session. Mild wrinkles and spots seem much more dramatic to them than they perhaps do to the casual viewer. Assuage your sitter by smoothing away those blemishes using the Rubber Stamp/Clone tool in your image manipulation application. With this, you can select a neighbouring area of skin and copy it, using it to cover any marks; indeed, the cloning tool in many applications can also mimic the colour and tone of the area you are repairing to create a truly seamless join.

CHAPTER 3: SHOOTING SOCIAL PHOTOGRAPHY

Let's face it; we all enjoy shooting and looking at photos of friends and loved ones. One way of capturing such photos is by shooting portraits, yet these have a certain formality to them derived from the fact that they are considered and posed. Social events or more informal gatherings provide us with plenty of other events to photograph people, be they friends, family or complete strangers.

Shooting groups of people at these kinds of gatherings calls for an extension of those skills developed for portraiture, but with a more impromptu approach, grabbing shots whenever the chance permits. You certainly won't normally have the luxury of being able to ask people to pose – and repose – for photos. Of course, this does not mean that we should be any less considered in our approach, but the consideration needs to come ahead of shooting; here 'be prepared' becomes our most significant by-word.

We can call this social photography, partly because we're shooting social groups and may well be doing so at social events. We'll take a very broad interpretation of that term here, including in the remit informal parties and gatherings (children's parties are, of course, a firm favourite) through to all those rite of passage events – weddings, christenings and coming of age celebrations. And we'll move beyond what is normally considered the confines of social photography to introduce events such as family sporting activities, school plays, and children at play.

Many formal social events have a professional photographer in tow, but their responsibilities mean they are tasked with producing photos that don't necessarily record some of the more sensitive and spontaneous elements. Being a friend or family member at any event provides you with a privileged advantage: an official photographer often subconsciously encourages people to be more formal, whereas with you or I they will be either indifferent to our camera, or more relaxed

31 EXPOSE YOUR SHOTS PROPERLY

For the most part, shooting people is simple and the results will be good. However this is making a couple of assumptions: you have good light levels and no extremes of brightness. What happens when conditions vary from this ideal?

Social events can present some difficult situations for achieving that perfect exposure. Weddings and formal events are perhaps a classic case with a bright white dress for the bride, a dark sombre suit for the groom, and bright ball dresses and dark dinner jackets for everyone else. It is all too easy for the exposure to be swayed by the dark tones or, equally, by the light ones. So, how can you avoid shots where the exposure is technically correct (in that the scene has the correct overall exposure) but no one element is properly exposed?

The answer is, you have to make a sacrifice. Often this is the background: you don't need this to be properly exposed and if it is dull, it will only set your subject off better. Alternatively, you can zoom in: if you don't want to capture full-length subjects, go close in for some head and shoulder shots. Then people will dominate your scene and you'll be more successful in your metering. You can also consider zooming in to take a meter reading from one part of your scene before zooming out to compose the shot.

Pro tip

IN THE PALM OF YOUR HAND
Here's a pro tip if you're struggling to get an acceptable exposure for a difficult scene. Stand so you're being lit by the same light source as your subject, then take a meter reading off your palm and increase the exposure by 1 stop. Perfect results! And that advice applies no matter what your skin colour.

Bright dresses: The dress is white, dazzlingly so, and reflective. The background is dark, almost black. A general exposure tends to take the background into consideration, which results in an overexposed subject (inset, above). Metering from the subject alone is little better: the great expanse of bright white leads to underexposure and a rather murky result (inset, below).

32 AVOID RED EYE

This is a basic fault that occurs when shooting groups of people, particularly in impromptu situations and where a burst of flash is needed. Don't let professional photographers kid you that it's something that never happens to them. Just about everyone can be caught out, so it's just as well to know the solutions.

Two things are needed to produce serious red eye. Low light levels, so that the eyes' irises are suitably dilated (though free-flowing alcohol at parties can exacerbate the effect) and a camera flash that's mounted on the camera close to the axis of the lens.

Unfortunately it's difficult to close the iris prior to shooting and you can forget red-eye reduction modes on your camera – they aren't particularly effective and at best only reduce the effect. We therefore need to focus on the lighting. Here's what you can do – in order of significance – to conquer this problem:

- **Increase ISO sensitivity:** And shoot without flash.
- **Use an external flashgun with an adjustable head:** Use it in Bounce Flash mode, bouncing the flashlight off the ceiling or another convenient reflective surface.
- **Use an external flashgun without an adjustable head:** Ensure it's as far from the axis of the lens as possible. Light reflected from the retina won't be coincident with the lens.
- **Fix red eye digitally during post production:** Many image manipulation apps have specific tools to fix this and for those that don't, it's easy to fix manually: desaturate the colour and use the Burn tool to darken the iris. Using this tool (rather than a brush) will preserve any highlights and reflections in the eye to achieve a more natural effect.

◁ Red eye: A typical shot that will deliver red eye. The burst of flashlight close to the axis of the lens produces a vivid reflection from the retina, much in the same way that headlights on a car will produce bright reflections from cat's eye reflectors.

▷ Reduced red eye: Asking your subjects to look to one side can reduce red eye substantially. Under close inspection you might notice a modest amount of residual red eye in this shot, but the extent is by no means detrimental to the image.

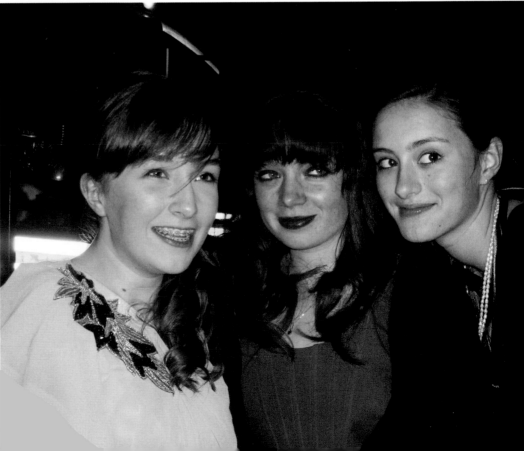

33 SHOOT GREAT CHILDREN'S PARTY PHOTOS

Children's parties are great places to take memorable shots. Most adults (and these days, quite a few children) will be taking photos, so make sure yours stand apart from the crowd by discovering some simple ways to turn the good into great.

Often children's party photos are a little limited: blowing out the candles on a birthday cake or a few shots of the children enjoying party food. Sadly, this means there have been so many missed opportunities. A child's birthday lasts all day long, so make the most of it! Here are some ways to make sure you get the most from the day:

- **Chronicle the day:** Don't restrict your photos to the party itself, shoot the whole day instead: from the birthday child waking in the morning, through opening presents, guests arriving, party games and meal, then concluding with the tired child retiring to bed.
- **Shoot at the child's perspective:** Remember what we discussed in regard to portraits of children (see Become adept at child portraits)? The same advice applies here, whether you're shooting informally or not.
- **Vary your shooting:** It's an event, so take group shots, shots of individual children and even capture the way pets interact with wrapping paper and new guests.
- **Use Burst mode:** To ensure you capture expressions spot on, use Burst mode to take a few shots in close succession.
- **Add some details:** If you're documenting the day, don't forget to get some shots of appropriate details – such as the birthday cake or colourful food.
- **Adopt a candid approach:** There is no reason not to get some more formal portraits (these tend to be more informal than the equivalent at, say, a wedding) as well as candid ones – of children at play and acting obliviously to the camera.

Candid shots: Shoot from a low angle to emulate the children's perspective when they are involved in an activity to capture some great candid shots.

Group shots: A posed group shot can prove problematic with younger children but can be successful when they are a little older. Use a shallow depth of field – wide aperture – to blur the background.

tip

LIGHTEN UP!
We mentioned this technique for romantic portraits (see Use software to create a soft, romantic portrait), but it also works well here as photos of younger children at parties can benefit from being given a bit of a lift. Here the photo has been manipulated by copying the image to a second layer and applying to this a modest Gaussian Blur. Then the Blend mode was changed from Normal to Screen.

Screen mode: This cunning but simple technique can provide images with a bright and upbeat look.

34 SHOOT GREAT WEDDING PHOTOS – WITHOUT THE PAIN

The pain? Well, think of all those forced smiles and absurd portrait poses that characterize traditional wedding photos. And the equally absurd length of time it takes to compose them. Let's try something different.

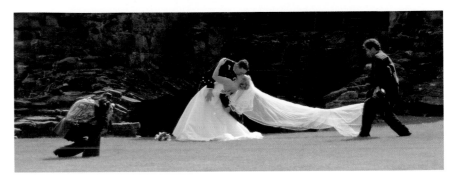

Unless you've been employed as official photographer (an onerous and, as you'll only be remembered for taking a photo of Aunt Millie scowling, thankless task) getting great shots at a wedding is more about catching the candid and impromptu scenes that, arguably, give a better picture of the event.

So what should you be looking for? The simple answer to this is to look for the details, as these are what the pro photographers don't have the time to explore. From the orders of service, through to place settings at the reception and to the details on posh frocks, all can produce great images that range from the descriptive through to the abstract.

Avoid stilted portraits – there will be plenty of formal portraits taken, so go for the utterly informal. This could be people chatting or laughing together, children playing – anything that breaks the stiff formality of the event. You could even consider taking a shot of the photographer taking photos of the wedding party.

Finally, go for extreme angles. Photographers love to get creative by shooting from high and low angles but most (or even all) conventional wedding photos are shot from eye level. Instead, stand on a chair and get an overall scene, or crouch low to catch the scene in the church. Taking this approach will ensure that your photos stand out from the rest.

△ Over the top: Wedding photographers can create some spectacular scenes and memorable photos, but it's a fine line to tread.

▽ Nice but twee: Weddings are colourful and exciting, yet we seem happy to accept rather stilted portraits as our record of a joyous occasion.

▷ Back view: These are not usually recommended, but can sometimes work. From the back view you can sense the nerves of this bride and groom.

▷ Opportunist shot: Keeping an eye on what's happening around you can produce interesting, spontaneous shots.

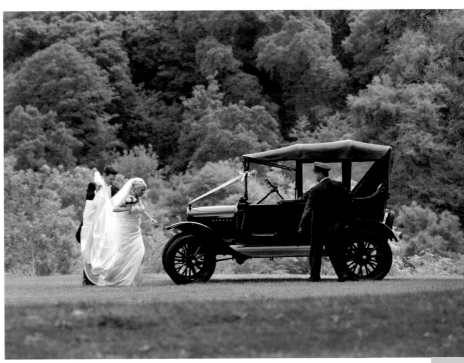

35 GET THE BEST FROM PUBLIC SPORTING EVENTS

Public sporting events – such as fun runs and half marathons – attract huge numbers of participants and an equally large variety of characters. With the surrounding crowds, these are social events on a grand scale. In fact, there is so much going on it can be difficult to know what to concentrate on. Set out with a plan to capture shots that aren't just crowd scenes.

The extent of a road run provides not only plenty of opportunities to find great shooting positions, but also the chance to shoot from many contrasting locations. As well as giving us the chance to capture amazing shots that illustrate the huge numbers that take part in such events, we also need to remember to focus on individuals in humorous and candid shots, as well as the mental and physical challenges. Here are a few suggestions for getting the best shots of road runs, and other major sporting events:

- **Use a telephoto lens:** Stand at a corner or bend of the road with a telephoto lens to record the mass of runners heading towards you. A narrow depth of field (wide aperture) lets you focus on specific runners in the crowd.
- **Select an elevated position:** This will give you the best shots of the sheer mass of the crowds of runners.
- **Get down low with a wide-angle lens:** The low angle gives your subjects a sense of power and dominance, but it's important to shoot runners close up.
- **Record changing expressions:** Smiles from excited runners often give way to pain and fatigue later on, followed by elation as they finish and collect their medals.

- **Shoot the unusual:** Sensible or not, many participants take part in fancy dress; some modest, some extreme. The contrast with the more 'traditionally' dressed participants produces great images.
- **Don't forget composition:** Although the subjects are fast moving, don't forget the basic rules of composition.
- **Capture group portraits:** Yes, portraits! But casual, grabbed ones that capture post-event euphoria – or, if you catch subjects during the event, their struggle to complete it.

WATCH OUT!
Zooming in too close can sometimes mean you can't get the composition right with these fast moving subjects. Zoom out a little, and then use the Crop tool in your image editing application to trim the image to achieve the best composition.

Stand tall: A slightly elevated position lets you capture much of the field. Focus on a specific runner to give the scene a focus – either someone you know or someone prominent.

Expressive shots: Confidence, fatigue, pride – these are just some of the expressions you can capture. Go for eye contact if you can for even more powerful shots.

Go for drama: By crouching down and using a wide-angle lens you can get dramatic shots of runners. The wide-angle lens will make them appear further away than they actually are (left) so make sure you get in close (right) without becoming an obstacle for the runners.

36 GET THE BEST FROM COMMUNITY EVENTS

In a similar vein, but making markedly slower progress along the streets, community events such as carnivals and parades are notoriously easy to photograph badly. The reason is often similar to that for road races: we snap away, in this case at passing floats and parades, but don't hone in on any point of obvious interest, instead trying to cram in too much.

There's nothing wrong with shooting the larger elements, such as floats. These are often lavishly decorated, and do make interesting images. However we want more than interesting – we want compelling. So, look more closely at the cavalcade as it passes to seek out the human angle – the bright, flamboyant costumes and the vivid colours. You need to zoom in close to avoid capturing too many colours and too many shapes. If there are plenty of different things to shoot, simply shoot each – tightly framed – in turn.

Parades: Without identifying obvious points of interest, photos of parades become merely a sequence of very similar shots.

Pro tip

A TOUCH OF FLASH

Brightly coloured scenes and characters, particularly when embellished with gilded panels and metallic trims, can often benefit from a touch of fill-in flash. Fill-in flash – particularly from built-in flashguns – won't necessarily offer enough light to illuminated the scene, but that's not what we're after. All we require is a hint of light to brighten the shadows and to enhance the colour.

Tight frames: Zooming in tightly on specific people or groups in a carnival produces more powerful images.

37 SHOOT DAYS OUT WITH FAMILY AND FRIENDS

Shooting photos of days out with friends and family can often result in photos that are almost voyeuristic in nature. Shot from a distance to include everyone, the photos become detached from the people involved. They can look as if you have just stumbled across a group of people; there is no practical or emotional involvement.

To capture images that are more involving is simple: you just need to get in close! It may be stating the obvious, but you do need to be right in the thick of the action. Of course getting great – rather than good – shots in these situations needs a little more thought. You don't just need to be close up, but involved too.

Explore the various opportunities by using your camera from different angles – holding it over your head, for example, or close to the ground. You may have to shoot blind if your camera doesn't have a fold-out LCD panel, but you'll capture at least a few successful shots. Also, if you want to join in the fun, don't forget to use the self-timer.

Fun on the beach: If we had shot this game of beach croquet from even a modest distance the result would not engage anyone looking at the photo; it would merely be a photo of a random beach activity. Getting in close to one of the players leads the eye to the main focus – the girl about the strike the ball.

38 SHOOT WEEKEND SPORTS

The same argument about detachment can apply to many photos taken of weekend sports, whether these are a game of children's football or a round of golf. Again we need to think before shooting if we are going to get something meaningful.

Too many sport photographs end up capturing views that we are familiar with on TV: wide scenes of a whole pitch or a long, sweeping fairway where participants are, at best, indistinct. Of course, for the person taking the photo it's often clear who their son, daughter or friend is, but for anyone else looking at the shots (for whom the personal angle is less important) they are unlikely to impress. No, to get something meaningful we need two things: firstly, to get in close and secondly to focus on the human angle in the shot.

Zoom in close: Expansive shots of a sports pitch will catch the action but relegate it to a less significant part of the scene. By zooming in close you can focus on the action, the expressions – and the inevitably shallow depth of field further focuses attention on the subjects.

Physically getting in close can often prove difficult, but your zoom lens can serve you well here. Zoom in to where the action is taking place – and follow it. Aim to compose your shots with, substantially, the players filling at least two-thirds of the height of the frame. What do I mean by the human angle? Simply that you don't want random shots of people chasing a ball or standing around on a court. What you really want is expressive shots of these people, kicking or heading a football, or striking a tennis ball. Then you don't just get the action but a powerfully expressive subject, too.

WATCH OUT!
When you zoom in tight on a subject you'll probably find that the aperture of your camera's lens is reduced from that at a shorter focal length. To keep images sharp with fast moving action raise the ISO sensitivity – to ISO 1000 or more. The image may appear grainier but that's better than being unsharp.

▷ Get in close: Don't miss the opportunity, particularly if you're taking part in the game, to get some shots in close.

Ignore the advice: If you think you'll get a great shot by being detached then go for it. Golfers love having a shot at the Swilcan Bridge at St Andrews Old Course, but the resulting images often look staged and clichéd. For this shot I asked my teammates to walk purposefully across the bridge, oblivious to the camera.

Pro tip

KEEP BOTH EYES OPEN
When you're using a viewfinder rather than an LCD panel to follow fast moving action and you've zoomed in close, your camera is looking at a very small area of the pitch. It can then be easy lose track of that action and it may take you a second or two to pick up on it again. Keeping both eyes open rather than closing that eye not pressed to the viewfinder lets you track the action, and more quickly get back should you lose your place.

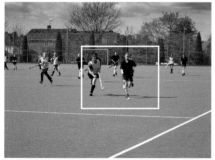

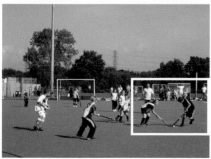

39 USE YOUR CAMERA PHONE FOR SOCIAL MEDIA

Nowadays the meaning of social photography has evolved to encompass the process of sharing images with friends and family on social media. This gives us the opportunity to look more closely at the camera phone, the principal tool of the social media photographer, to discover how we can exploit it to capture powerful photos.

Professional photographers, often with good reason, tend to deride camera phones. Although some models buck the trend, on the whole camera phones can't match stand-alone cameras in terms of lens quality, sensor size and the degree of control on offer. However camera phones do have some powerful advantages, which include:

- **Ubiquity:** You'll seldom be without one, even for those events when you don't have a camera, making them great for those otherwise lost opportunities.
- **Discretion:** When you do have your camera it's not always appropriate or safe to use it; a camera phone can be much more discrete.
- **Sharing:** You can share your images virtually immediately, whether by emailing, sending with an SMS message or by posting to a social media website.

Of course, it's the latter virtue that's of greatest interest to us here. In fact, much of what we have discussed throughout this book in regard to different types of photography applies equally to any photographs taken with a camera phone. The caveat is that the camera itself may not always allow you the degree of control that is possible with a stand-alone camera.

To become an expert at using a camera phone you simply need to be aware of where a camera phone excels, and where it will struggle to deliver – and then live within those restrictions. Key pros and cons are listed below, but it's often useful to consider your camera phone as a route to extra opportunities rather than any form of replacement to your conventional camera.

CAMERA PHONE PROS AND CONS

Pros
- Discretion
- Always available
- Option to apply instant effects
- Immediate distribution
- Great for 'everyday' shots
- Good for shots in bright conditions

Cons
- Limited control
- Small sensor can lead to noisy images
- Small lens
- Not so good in poor light
- Limited zoom control
- Low resolution on many models

40 CREATE DRAMATIC PHOTOS WITH YOUR CAMERA PHONE

For many users of smart phones, much of the fun derived from taking photos with the device comes from the ability to use apps to transform those images before sharing them on social media sites.

There are plenty of apps that modify images shot on your camera, some useful, some less so. There can be a bit of trial and error in finding genuinely useful ones – those that will make a good image better, or at least more interesting – and some of the more popular apps offer both good and bad features.

What applications like this help us to do is experiment in ways that would be somewhat more longwinded (and need greater expertise) if done using image editing applications. The example below shows this: a simple image shot on a camera phone is first enhanced and then modified using a distorting filter. For these effects I've used the Snapspeed app.

Tilt shift: The effect has become something of a cliché through overuse, but tilt shift effects are undoubtedly eye catching.

Start point: One of those shots that makes you look twice; this image shows large natural blocks of ice on the coast of Iceland near Dyrholaey. Although this is a surreal scene that begs to be photographed, the straight image isn't that compelling.

Adjusting the tone: The Drama Filter effect in Snapspeed was used to create a moody sky and better contrast in the ice; this dramatic scene is closer to that which was actually experienced.

Transforming the scale: Using the Tilt Shift Filter effect, I was able to create an extreme depth of field effect that gives this upscale scene a more modest, even macro appearance. Is this a questionable filter effect? Perhaps, but if it works and produces a great image, should we condemn it? I'd say no.

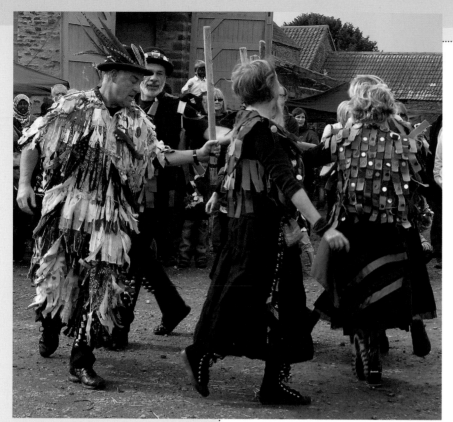

Getting together: Whatever your interest, and whether you are a participant or an interested onlooker, you can shoot some great photos. Knowledge of the way an event will unfold and a good viewpoint will help you to capture the best shots.

41 SOCIAL PHOTOGRAPHY

Weddings, christenings, parties, or just friends getting together – social photography is about capturing memories. So how do you capture the essence of a special day – or special occasion? You need to enjoy the event and shoot memorable photos. Enjoy the day and shoot photos whenever there's an opportunity, but do spend a moment or two thinking how you can get the best from that opportunity.

ESSENTIALS
- Go for relaxed shots and compositions.
- When shooting an occasion – a wedding, for example – get to know what will happen and when, so you don't miss out on any opportunities.
- Ensure there's an obvious subject in each shot; something for the eye to land on as a base for exploring the image.

TAKE CARE!
- **Use flash with care:** Avoid, if you can, using direct flash on-camera. Increase ISO sensitivity and shoot with available light wherever possible.
- **Exploit transient lighting**: Brief changes in weather and lighting can produce dramatic changes in the scene.
- **Watch out for potential distractions:** Take a moment to survey the scene either directly or via the camera to ensure there is nothing that might compromise the shot.

EXPOSURE MODES
- **Aperture Priority mode:** Use Aperture Priority mode to control the depth of field in the scene. Go for small apertures when you have large groups or spaces to keep sharp, or wide apertures with shallow depth of field when you want to isolate selected people.
- **Auto mode:** Select Auto or Program mode for grabbed shots when you don't have the opportunity to configure the camera. Make use of exposure compensation to keep bright scenes bright or dim scenes (such as church interiors) dim.

IN YOUR KIT BAG
- **As little as possible:** At social events, unless you are taking officially sanctioned photos, it's best to travel light – with just a camera and general purpose zoom.
- **Flash:** If you are not taking a kit bag, keep a small external flash in your pocket for opportunities when you may want to augment the ambient lighting.

GOOD TO GREAT TIPS
- **Choose formal or informal:** If you're photographing an event, such as a wedding, should you go for formal or informal? My gut feeling is always the latter. Photography is about recording, not dictating, the event, which is so often the case when formal portraits are called for. If you've been called on to be the official photographer, take guidance from the bride and groom; if you're a guest, shoot informally and let others take care of the formal bit.
- **Get familiar with exposure compensation:** Bright white wedding dresses, or white dresses generally, can fool exposure systems. If you have the opportunity, take test shots with +2/3 stops of exposure compensation to keep

the dresses bright and white. Don't go too far or you'll risk losing any detail in the dress and get a featureless expanse of white.

- **Go for candids:** Candid shots rather than forced poses lead to great photos: children misbehaving, arguing relatives, family and friends making fools of themselves dancing, and so on. They may not thank you at the time but when you look back at the photos you'll have captured some memorable moments.
- **Gather insider knowledge:** At most gatherings – parties, receptions, wedding breakfasts or straightforward get-togethers – you can normally shoot away with impunity. However if you are shooting a wedding service, a christening or any other event in a place of worship, make sure you follow the rules of that venue, restrictive though they may be.
- **Consider what to do with the photos afterwards:** Photos of an event will provide lasting memories but are fun to share straightaway. Posting them online – whether on a social networking site, a photo sharing site or even your own website – will give people an opportunity to relive the event and give you a chance to show off your photographic prowess.

Pro tip

TELL A STORY
Many events, even informal ones, have a structure and timeline so use your photos to tell the story. Of course, some ad-hoc photos of any event are great for both memories and any family album, but you can get even more memorable results if your photos follow a logical structure. For example, for a wedding, take shots of the preparations early on in the day, then shoot the event itself and the party afterwards.

Always carry a camera: You never know when something spontaneous may happen – such as a group of shoppers coerced into dancing in a busy street – so having a camera to hand will reward you with some unexpected shots.

CHAPTER 4: PHOTOGRAPHING THE GREAT OUTDOORS

A beautiful landscape is a draw to almost every photographer, as well as quite a few camera-armed people who wouldn't even consider themselves photographers; the bright colours, sweeping vistas and humbling grandeur of landscapes are powerful magnets. The same can go for many cityscapes, where modern buildings nestling for space with older heritage buildings produce intriguing juxtapositions that again tease us to turn the camera upon them. So often, though, the photos we record will disappoint: that sweeping landscape is there, on our camera and on our computer, but somehow it is not the same as we recall.

The reason for this is the different ways that our eyes – or rather our brains – and our cameras visualize a scene. When we view a bold landscape our eyes tend to roam about the scene and take in disparate elements: a stunning waterfall to the left, a precipitous cliff to the right, and so on. In addition, we are often moved by such views and our perception of it therefore takes an emotive angle, too. Our camera, conversely, is more dispassionate: it sees the same scene but shoots it in an utterly objective way. This explanation applies to any imagery, but the effect is most pronounced when viewing imposing or evocative scenes.

So, taking a good landscape photo demands a little more consideration and appreciation of a scene. We need to overcome the initial sense of awe and look objectively at the elements that comprise the scene then we need to look at the way these fit together. We also need to overcome the natural desire to include anything and everything in the landscape. In this chapter we'll be looking at how to view and craft great landscape shots. However we won't limit ourselves to what we might term traditional landscapes, as we'll also explore the urban landscape and even some of the activities you'll find in each.

42 CONCEIVE GREAT LANDSCAPE PHOTOS

If you ask any photographer what his or her favourite genre is most would, if pushed, say landscapes. Often, though, what people actually shoot are just travel photos, rather than landscape images. In landscape photography we should aim to go beyond mere records of scenery to capture the true spirit of the location.

Seasoned landscape photographers will have a few things in mind when they set off to capture a stunning landscape. Together these items will ensure that their shots will do justice to the scene. We might call them tips, and they are certainly worth reiterating. Some you'll use on every shot, while others may present themselves less often:

- **Great landscapes are all around:** You don't need to head to the Rockies or the Dordogne to find a great landscape. Look out of the window: there will be something, rural or urban, to practise on.
- **Get the technicalities right:** A good landscape photo should be in sharp focus from the nearest part of the scene to the most distant. For best results, focus on the middle distance and select an aperture of f/16 or smaller. In addition, use a tripod or some other firm support to ensure pin sharp results.
- **Compose every shot:** Remember those rules of composition? They are particularly valid here. Try and follow the rule of thirds, say, as you develop your landscape photographer's eye, but don't be afraid to try something different if the scene suggests it.
- **Use lead-in lines:** Lead-in lines help to draw people's attention to the subject of your landscape – and every landscape needs a subject where the viewers' eyes can land. Your lead-in lines might comprise a rambling river, railway lines or even a road that leads towards the subject of the photo.

- **Shoot at different times of day:** The way a familiar scene can change according to the time of day can surprise even the most seasoned of photographers. Early morning or evening light can cast a warm glow over a scene and provide long shadows. At midday the light can be less melodramatic, but there's certainly still scope to shoot. Don't be afraid to revisit a site several times to capture it under different lighting conditions.
- **Watch the weather:** Similarly, changing weather and seasons can literally cast a different light on a scene. Contrast bold summer sunshine with wintry shots featuring mists, frost and even snow.
- **Use filters:** Use a polarizing filter to help enhance colours and remove reflections, particularly from water. Use a graduated filter to reduce the relative brightness of the sky to provide more even exposures (see Enhance landscapes with graduated filters and Enhance colour with polarizing filters).

Changing landscape: OK, it's not a classic view – it's the one out of my window – but throughout the day and over a week it can change dramatically.

43 REFINE YOUR LANDSCAPE SKILLS LOCALLY

Practice certainly makes perfect when it comes to developing landscape skills, but don't make the task onerous. Instead of travelling far, spend some time exploring your local neighbourhood and take some great shots within a short distance of your own home.

Landscape photography needs a rapid response from exponents to capture; for example, that perfect break in the clouds near sunset casting an auburn glow over the landscape. It will last just a minute or two so you need to be able to respond quickly. That's why getting to know your neighbourhood is so important.

Look for those elements in your local landscape – or cityscape – that you can craft into stunning landscape photos and shoot them under different lighting conditions. Get up early to catch them lit by the golden glow of sunrise, then return at the end of the day to capture them silhouetted by the setting sun. Shoot into the light and shoot with side lighting – and then closely observe the results.

Through the day: Concentrating on a local scene can help you appreciate the effect of changing light and weather conditions. This is one of my favourite spots – the harbour and cathedral in St Andrews, Scotland. Shot in the morning light, against evening storms and at times between, the character of this landscape can change dramatically.

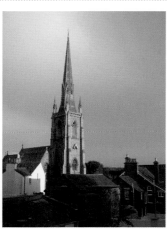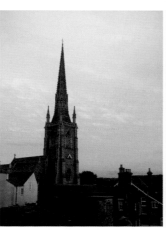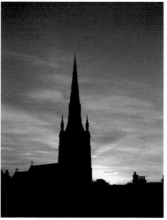

44 CHOOSE THE BEST FORMAT

Because, more for convenience than anything else, we say that an image shot with a camera's normal orientation (that is to say wider than it is tall) is in 'landscape' format, many people shoot all their landscapes this way. This is something of a shame, as not all landscapes best suit this format.

Best format: It's clear from some subjects which format is most appropriate. This evening scene looks OK in landscape format, but it looks even better in a wider, panoramic shot.

So how do you determine which format is best? Often the scene itself dictates which is most appropriate, particularly the way objects in that scene relate to one another. For example, a broad scene is ideally shot in landscape format, whereas an even wider one might benefit from shooting in panoramic format; alternatively, a scene with strong front-to-back lead-in lines may better suit a portrait format. The lens we use can also have some bearing on the outcome. For example, using a wide-angle lens to shoot in landscape format can include too much detail, whereas shooting in portrait format can be more effective, creating a logical flow from the foreground to the horizon.

Panoramic shots (see also Create vertical panoramas) are certainly dramatic, but also potentially more problematic because so much more detail is included; it is therefore essential when conceiving a panoramic shot to exclude as much superfluous detail as possible. When I look at a scene I often consider that it might make a great shot in the conventional landscape format, but for the bland expanse of sky or foreground. Bold elements are a pre-requisite of panoramic images to provide them with focus and to prevent them being viewed as a collection of disparate elements.

Wider view: A wide-angle lens would be needed to accommodate this timeless scene of the approach to the Grand Canal in Venice. However, with the featureless lagoon waters and a less than impressive sky, these areas would add no value to the shot. Shooting as a panorama gives a more pleasing effect, our eyes being drawn to the Campanile, which is compositionally balanced by the Church of Santa Maria del Salute to the left.

45 CREATE VERTICAL PANORAMAS

When we create panoramic images we automatically begin by assessing how wide they should be. Instead, have you ever considered that some tall scenes or subjects lend themselves to the creation of vertical panoramas? Vertical panoramas – whether produced by cropping down a standard portrait format shot, or by building up from a stack of vertically aligned shots – is an ideal way not only to record bold, vertical subjects, but also to emphasize height.

Vertical panoramas are also a great way to record shots in confined spaces. Often, if you and your camera are trying to shoot a tall building in close quarters, you either have to compromise by recording only part of it, or resort to using an ultra wide-angle lens – a type of lens that is likely to introduce a degree of distortion. Creating a vertical panorama instead allows you to get the best of both worlds: a shot in a tight space and one composed of images shot with less exotic (and less distorting) lenses.

Pro tip

DIAGONAL COMPOSITIONS
If you are caught out with an inappropriate lens for a shot of a tall building or some other lofty subject, shooting on the diagonal can give a pleasing result that emphasizes height.

Campanile: Now we've moved closer to the Campanile it's too tall to shoot easily. By using a diagonal composition we can get the best coverage and emphasize the building's height.

Vertical panorama: Four individual images, shot at a modest telephoto setting, were combined to create this vertical panorama of St Salvator's Chapel tower in St Andrews, Scotland. A single shot with a wide- (or super wide-) angle lens would be distorted and lack the linearity of this shot.

46 EXPLOIT PANORAMIC FORMATS

A wide panoramic photograph is almost always guaranteed to make people gasp and say 'wow'. A breath-taking vista, properly shot, is one of the most powerful images around – but shooting a panorama is not an excuse to throw all your other photographic techniques aside.

In technical terms it's simple to shoot a panorama. If you're lucky – or wealthy – you can use a dedicated panoramic camera and shoot one directly. Or more likely, you can create a panorama by conjoining adjacent images of a scene, doing so either in camera or later, using image editing software.

Whether you do choose to complete this task in camera (assuming your camera has the feature) or using software, the approach is the same. You need to shoot a number of images that together cover the whole panorama. Overlap each image by about 20 to 30% so that the images can be properly joined.

You can hand hold your camera to do this – although prepare for a degree of misalignment that could compromise the final result – or better, use a tripod, rotating the camera horizontally a little between each shot. There are custom panoramic photography tripod heads, but a standard or a pan-and-tilt head designed for video cameras is just as good. Shoot the images in reasonably quick succession so that there is little chance of the subjects moving noticeably between the shots.

Don't forget the rules of good composition. A sweeping panorama may be compelling when you look at it for real, but in a photograph there still needs to be a focus, something that immediately draws the eye. Some foreground interest can help lead the eye to the more distant parts of the scene, as in a conventional landscape shot, and adds perceived depth.

Pro tip

BETTER PANORAMAS
When combining several images, any distortion – no matter how slight – introduced by the camera's lens can be compounded and will affect the quality of the final panorama. To reduce the risk of this, set the camera or lens to a modest telephoto setting. You may have to hold or support the camera in portrait (upright) format to get the necessary height in the image and shoot more images, but you'll be rewarded with a much better and more detailed panorama.

tip

MANAGING EXPOSURE
The angle of view of a panorama is so wide that it can take in parts of a scene in bright sunlight through to those that are less bright. Normally a camera set to Auto Exposure would compensate for each shot, resulting in uneven exposure so for better results lock the exposure at a median level.

◁ Build a panorama: Begin with a series of source images, with a healthy 20 to 30% overlap between each shot.

▽ Complete panorama: The joined panorama should look as if it was taken by a single shot. Any image manipulations should be applied after the images are joined.

Depth: Shooting objects and subjects at different distances from the camera provides depth, thus improving the overall composition.

tip

SUCCESSFUL PANORAMA EFFECTS

If you are using software to combine images into a single panorama, you will sometimes get an oddly distorted result. If this happens, take a look at the settings for the panorama generator: selecting an alternative method of stitching the images together (such as switching to Cylindrical mode, as shown here in Photoshop's Photomerge) will give a more realistic result).

Panorama configuration: If your panorama looks unduly distorted, select Perspective or Cylindrical (rather than Auto) mode from the Panorama Layout dialogue box.

47 ADD DEPTH TO AN OUTDOOR SCENE

All too often shots of the great outdoors end up looking rather flat. A scene that was breath-taking when photographed leads to a somewhat underwhelming shot. What went wrong?

Nothing, per se. When we view a scene, most of us will perceive it in three dimensions. Foreground interest will help lead the eye to the more distant elements and provide one or more planes that add depth to the scene. If we don't include such planes when shooting, the image ends up being rather two-dimensional.

It's important, then, that we use foreground detailing to help frame our shots where we can. What do we mean by frames? In practice it could be a tree, arching over the scene, or perhaps a gateway. It might even be the foreground landscape, a rolling meadow for example. Not strictly a frame, but something that will provide that added depth. Take a look at the examples here that use frames and see how they add to the depth of the scene.

Pro tip

ASSESSING YOUR IMAGE
Not all landscape or outdoor images need frames: adding a frame to every image could make your portfolio monotonous and somewhat forced. If you think about framing your shots, it will soon become obvious which photos need a frame and which simply need foreground detailing. Or even those shots that might require neither.

Arches and doorways: Almost a cliché, archways and doorways are obvious ways of leading the eye through to the subject and are a great compositional device.

Foreground interest: We can talk glibly about foreground interest. What you use should be interesting or even intriguing. Here a receding field of purple parasols provides interesting and unusual foreground interest for the subject, the ArcelorMittal 'Orbit'.

Framing with foliage: Shooting though foliage provides a natural frame that draws the eye to the subject here. With so much dark material in the frame, it is important in cases like this to take an exposure reading from the subject.

48 USE SOFTWARE TO ADD FOREGROUND DETAIL

Sometimes there's no obvious way to add depth in a scene, you find that you can't contrive a way to introduce some foreground detail or any detail that you do provide just looks… well… contrived. So here's a way to introduce depth using a simple but cunning piece of digital sleight of hand.

Though we often describe how, in landscape shots, sharpness throughout the scene is important, using out-of-focus detailing in the foreground can also be effective in conveying that important sense of depth. A blurred foreground gives the impression that you are looking through, or over, a foreground plane, close to the camera, to the more distant scene.

Consider this image of a weatherboarded boathouse on a lake. Charming, but missing something: some foreground interest. Unfortunately, the footpath directly abuts the lake and so there's nothing close up that we could feature.

I think that this image would benefit from some complementary lakeside planting, some wild flowers perhaps. We could add such detailing by some rather advanced image manipulation, cutting and pasting

from another image. It could be a big job, particularly to impart sufficient realism. Here's a much simpler way to achieve a remarkably effective result:

1. Open your image in your image editing application.
2. Create a new empty layer in the image.
3. Select the paintbrush tool and a large brush size. Some applications allow you to paint with a leaf shaped brush which is even better.
4. Select a random painting option – when you paint with this you'll get a random scatter of brush marks rather than a continuous stream.
5. Lightly paint across the foreground of the scene to depict flowers and leaves.
6. Apply a Gaussian Blur filter to blur the brush strokes.

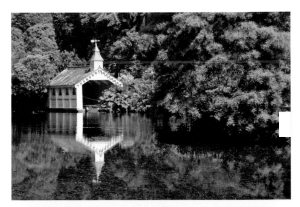

The boathouse: A tranquil scene but lacking in depth.

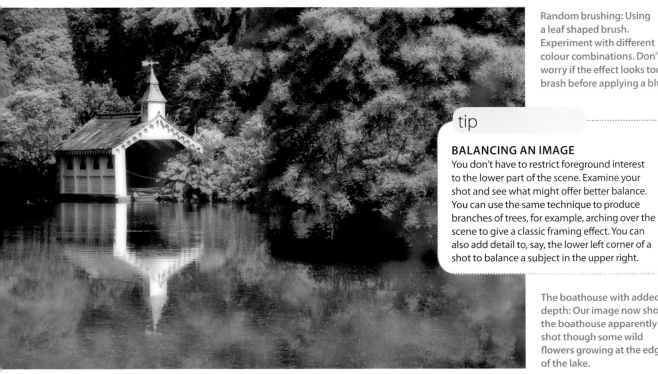

Random brushing: Using a leaf shaped brush. Experiment with different colour combinations. Don't worry if the effect looks too brash before applying a blur.

tip

BALANCING AN IMAGE
You don't have to restrict foreground interest to the lower part of the scene. Examine your shot and see what might offer better balance. You can use the same technique to produce branches of trees, for example, arching over the scene to give a classic framing effect. You can also add detail to, say, the lower left corner of a shot to balance a subject in the upper right.

The boathouse with added depth: Our image now shows the boathouse apparently shot though some wild flowers growing at the edge of the lake.

49 ENHANCE TONE WITH QUICK FIX APPS

Often well-conceived and shot landscapes can lack punch; they look good, but don't look great. Similarly, some shots taken under moody lighting can seem drab. Used with discretion, the often-derided auto fix software features can bring these images some instant zing, and you don't need to be a digital whiz to get great results.

It's surprising – or perhaps it's not – that when we shoot a landscape we can often be disappointed when we look at the picture. It looks broadly as we remember it, but it is somehow just not quite as good. Sometimes our memory lets us down; the camera sees a scene without the emotion that we feel. At other times we are right; the camera has not represented the image as well as it should have.

Of course this is not the camera's fault, but it is interesting to learn that the camera has in fact stored a better image than the one it has chosen to share with you. Generally, the tonality across the image has been compressed and this is something you can quickly fix using image manipulation software and the Auto Tone command. I am slightly hesitant in suggesting an auto fix command because they can be rather abrupt, but the good thing about this control is that you can always remove it if it doesn't work.

Auto Tone: A rather bleak scene becomes more colourful and almost inviting when the tonal range is corrected with the Auto Tone command.

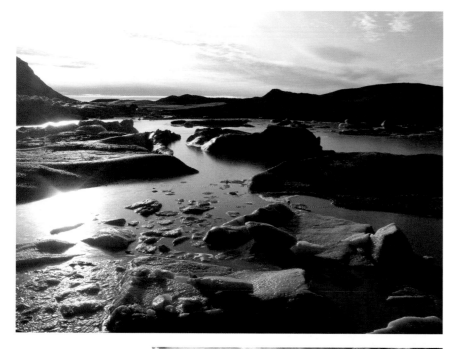

ON YOUR PHONE
There are a number of image enhancing apps featuring commands that produce a similar – and instant – effect. Here I've used the iPhone application Snapseed to brighten up an otherwise contrasty sunset. Foreground and cloud detail, not visible in the original, has been revealed after application.

Snapseed: This app allows us to add punch and restore otherwise lost detail.

50 ENHANCE TONE WITH DIGITAL MANIPULATION

Applying an overall tonal correction is one of those enhancements that really reveals the power of digital image manipulation, made all the better for being in the form of such simple command. However it is not always successful, being such a blunt tool. It simply lacks the flexibility of a critical eye that is adept at recognizing where corrections need – or need not – be applied.

So, what's the alternative? The answer is going back to the days of traditional darkrooms. There master photographers would, when printing their images, use their hands or pieces of card to screen off parts of the image, or they would allow more light to fall on other areas to achieve a more dramatic effect. Allowing more light to hit part of the image caused (in negative form) darker areas, a process known as burning in; shielding areas, thus rendering them lighter, was called dodging.

These tools have made the transition to the digital world and image manipulation software includes Dodge and Burn tools. You can apply these with brushes, choosing the size and shape of the brush and even the softness. You can also – and this is one up for the digital worker over his or her traditional darkroom counterpart – selectively apply the effect to the lighter parts of the image, the mid-tones or the shadows. This is great when, for example, you want to burn in details on bright clouds, without affecting adjacent darker areas of sky.

There is no doubt that there is a skill to using Dodge and Burn tools, but it's one that is easily learnt. And, by using the Step Backward command, if you overdo it at any point it's easy to retrace your steps. Just be gentle with the technique – and don't apply the commands at more than 10% strength.

Pro tip

SATURATION CHANGES
Changing the tones in an image – either automatically or using digital darkroom tools – can affect the colour saturation. You can end up with regions of under- or oversaturated colour where you have, respectively, lightened or darkened an area. Use the Saturation Sponge tool to (gently) compensate.

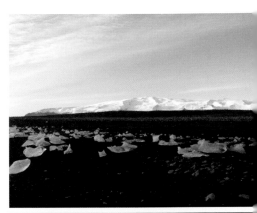

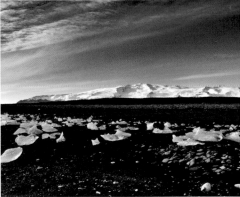

Sunset: A colourful sunset becomes so much more when the sky is burned in. The featureless foreground, when dodged, reveals details and structures not visible in the original shot. If the colour is too lurid for some tastes it can be reduced using the Desaturation control.

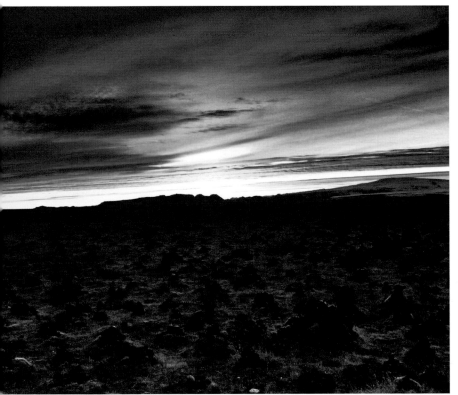

Lava field: Selectively applying Dodge and Burn to highlight, mid-tones or shadow areas allows us to reveal details selectively.

51 DISCOVER THE BEST URBAN PHOTO OPPORTUNITIES

Cities – we either love or hate them. The hustle and bustle, and downright chaos, is what many strive to avoid, but amidst this there are some fantastic photo opportunities to be found. Moreover as most of us live in urban centres, those opportunities are very literally on our doorstep. Don't think of urban photography as merely a specialized form of landscape photography, as it's very much in a class of its own.

A class of it's own, yes, but the skills you have developed for landscapes are equally valid here. For example, like rural landscapes city scenes will change throughout the day, not just because of the lighting but also because of the ways cities operate. First thing in the morning the city will be quiet, but it will gradually come to life; in the evening the city lights up, creating interesting contrasts between the natural and various kinds of artificial lighting.

As you explore the urban landscape look for interesting combinations of buildings: tall and short, old and new, pristine and dilapidated. Also seek out views where dramatic, modern – and expensive – buildings rise above old and run down ones; contrasts like these work really well in photographs. Don't always shoot wide views, either – close ups and architectural details can also produce powerful shots.

Finally, remember that cities are where people live and work. People are therefore just as much a part of the cityscape as the architecture, so there's no need to exclude them from your shots – they add colour and character. Try to shoot city dwellers candidly going about their everyday business rather than have them pose for shots, keeping your camera as unobtrusive as you can.

tip

JOIN AN ORGANIZED TOUR
As well as doing your research in advance by reading guidebooks and visiting relevant websites, an organized tour can be a great way to seek out the famous and not-so-famous parts of a city. A group can also be a more secure way of touring parts of a city that, alone, might be more risky.

Pro tip

LOOK UP
In confined spaces and with your camera equipped with a wide-angle lens (or with a fixed lens set to its widest view) point your camera up. You'll get some incredible converging shots of the surrounding buildings that emphasize – or even exaggerate – their height, something you rarely have the chance to do in a rural landscape!

Architectural detail: Zoom in to architectural details for some powerful abstract shots, such as here on the roof of the Welsh Assembly Government building in Cardiff.

Foreground interest: As for conventional landscapes, exploit foreground interest to add depth to a scene and to lead the eye to the subject.

Point upwards: Don't just shoot traditional vistas; point your camera upwards to capture some really powerful shots, too.

52 PHOTOGRAPH VIBRANT URBAN ART

Striking artworks enliven our cosmopolitan cities. As compelling as they are frivolous, these works may be specially commissioned or completed on more spontaneous grounds. Although some street art is technically illegal, it can add – quite literally – amazing colour and vibrancy to the cityscape.

You have considerable creative scope when shooting urban art. On one hand, you can accurately record the artwork as a whole or pick out individual details. On the other, you can investigate the way the artwork sits within its environment, perhaps adding a candid social comment on the relationship. For the latter, consider using wide-angle views close up to the art and low camera angles to include as much of the surroundings as possible. However don't be afraid to move away and shoot from a distance, too.

tip

SHOOT THE SETTING
For murals and graffiti it's a good idea to shoot the setting, too. A close up of any public artwork may make a good image, but is essentially just a copy of that artwork. It could (technically at least) violate copyright, and doesn't really convey anything about the context.

Where and what?: Great art with great colour, but where is it and what is it? A close up of an artwork is visually stunning but doesn't say much about its environment.

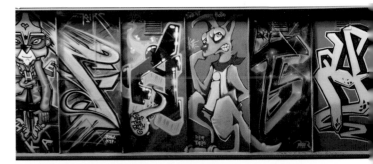

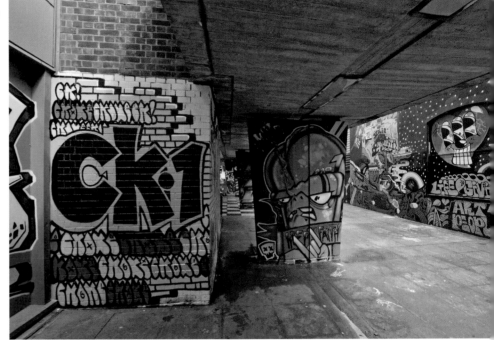

In context: Shooting a wider view shows more of the location and setting.

Urban art: This can take many forms, and can be a gift to the photographer; this is not a shot of a post-apocalyptic scene but a commissioned artwork.

53 EXPOSE LANDSCAPES WITH GRADUATED FILTERS

Photographers' kit bags used to be packed with filters capable of all manner of image modifications, many somewhat dubious. Now that those somewhat suspect modifications – and more – can be completed digitally, most screw-on filters have been rendered redundant. However this is not the case for the graduated filter and the polarizer (see also Enhance colour with polarizing filters).

The reason these filters are not, and should not be, consigned to the darkest corner of your redundant photo kit drawer is that they do significantly enhance your landscape images with an effect that is not easily reproducible using image manipulation software.

The graduated filter is designed to overcome exposure problems in landscape photography where a bright sky and less bright landscape mean that the correct exposure for both cannot be accommodated in a single shot. You would either have to accept a dark landscape and correctly exposed sky, or a properly exposed landscape and washed out sky. Placing a graduated filter over the lens – so called because it is dark in one half and gradually

fades to transparent in the other – evens out this imbalance.

These filters are usually rectangular and fit in sliding mounts (such as those popularized by Cokin and Lee) so that the graduated section can be adjusted up or down according to where the boundary between landscape and sky occurs. They are available in different strengths (that is, different densities in the dark section) to provide for greater or lesser brightness differences. They are also available in different colours – to give a sky a threatening sepia or brown cast, for example – but I would tend to stick with the basic grey. If you really want a coloured sky, add a tint later digitally, then you can always remove it again if it looks peculiar.

Pro tip

METERING WITH A GRADUATED FILTER
Take your meter reading from the part of the scene – usually the landscape – that you want to be correctly exposed, then put the filter in place. This will avoid the filter affecting the exposure.

Graduated filter: Adding a graduated filter evens out the brightness in a shot and allows you, as here, to get the best from the otherwise underexposed landscape (in terms of colour and contrast) as well as the sky.

54 ENHANCE COLOUR WITH POLARIZING FILTERS

Another filter that still very much has its use. Unlike graduated filters that are designed to modify part of an image, the polarizer can be used to boost colour and depth throughout the entire scene.

Polarizing filters essentially filter out polarized light, that is to say the part of the light whose waves move in a certain direction. This component generally comprises light reflected by surfaces in the landscape and particles in the atmosphere, producing the net effect of more saturated and deeper colours in your image.

These filters are conventional circular ones, and as such you'll need a different one for each lens if your lens mounts have different diameters. Rotating the filter will vary the amount of the effect: at one position it will filter out none of the polarized light, but at another (usually a 90 degree turn) it will filter out it all. You can set it to any intermediate position to achieve a greater or lesser effect.

Because of their ability to filter out reflections, polarizing filters can also be used to give water a more transparent appearance: surface reflections can be eliminated and boats, for example, can appear suspended in the sea. I should add that this does require very clear water!

Pro tip

CONTROL POLARIZATION
In clear conditions a polarizing filter can turn a sky almost inky black – quite unnatural. In such situations, adjust the angle of the filter by turning it in its mount to create a lesser and more realistic (colourwise) amount of polarization.

Polarizing filter: Adjusting the angle of the filter will increase colour saturation by reducing reflected, polarized light.

55 OUTDOOR PHOTOGRAPHY

Shooting outdoors gives us great scope – sometimes too much scope – for capturing some excellent photos. However to achieve the best, and to avoid being overwhelmed by sweeping scenery, it's a good idea to start with a vision. Remember landscape photography – which will comprise most of your outdoor photography – isn't just about grabbing a wide view; it can be as much about capturing the essence and spirit of your location.

Explore locations: Take time to explore a location. Some subjects, such as the iconic Lady Isabella Waterwheel on the Isle of Man shown here, are difficult to successfully photograph close up. However shooting a more distant view with a telephoto lens gives quite literally a different perspective.

ESSENTIALS

- Think about what you intend to shoot. Do you want a simple representation of a landscape scene or to focus on an element within the landscape?
- Unless attempting something creative, keep the entire scene sharp.
- Go for strong compositions and ensure there's an obvious subject in each shot for the eye to land on as a base for exploring the image.

TAKE CARE!

- **Avoid wide contrast ranges:** Or compensate for them, using filters.
- **Exploit transient lighting:** Brief changes in weather and lighting can produce dramatic changes in the scene.
- **Beware of potential distractions:** Take a moment to survey the scene either directly or via the camera to ensure there is nothing in the shot that might compromise it.

EXPOSURE MODES

- **Landscape Scene mode:** This mode will quickly configure your camera for perfect sharp landscapes. When you select this mode the camera will select a small aperture to give foreground-to-horizon sharpness, setting the focus point in the middle distance.
- **Aperture Priority mode:** For most landscape shots you'll set a small aperture to ensure as much of the scene is in focus as possible. When concentrating on details – perhaps some flowers in a meadow or a sculpture – you may need a wider aperture to separate the subject from its surroundings.

IN YOUR KIT BAG

- **A firm support:** A tripod or an equivalent, as keeping everything sharp and detailed can mean long exposures.
- **Polarizing filter:** Perfect for enriching blue skies and cutting through reflections on the water.
- **Graduated filters:** Great for evening out differing brightness levels between a bright sky and a duller landscape.

- **Wide and telephoto lenses:** Shooting wide panoramas is just one small part of outdoor photography.

GOOD TO GREAT TIPS

- **Explore at different times:** For example, in the morning a cityscape can be tranquil and almost surreally quiet, making an interesting counterpoint to shots taken later in the day.
- **Explore your surroundings:** The easy photo opportunity may not show your subject or scene to best effect, so explore to route out some alternative, more interesting shots.
- **No need to rush:** Unless weather conditions are changing fast, landscape photography gives you the chance to be methodical and considered when you shoot your scene.
- **Experiment:** Changing camera settings can produce interesting and photogenic results. Flowing water, for example, will take on a quite different look when shot using fast shutter speeds and longer exposure times, looking either frozen or silky smooth respectively.

Expect the unexpected: Fast reactions can help you capture shots like this – even though the original intention was a study of the decaying castle walls.

CHAPTER 5: TAKING GREAT PHOTOS ON YOUR HOLIDAYS AND TRAVELS

Cameras and holidays have always gone together. Historically, even those who would rarely show much interest in photography – and would never call themselves photographers – would grab a dusty camera from a drawer when heading off for a summer break. Not that they would use it much: film processors told tales of processing and printing film rolls that had a Christmas celebration at the start, a summer holiday in the middle, and another Christmas get-together at the end of the roll!

Today things are quite different. With a camera or camera phone that can be carried everywhere, people are likely not only to shoot photos but also make a visual diary of their every move whilst travelling. The result may not be a collection of brilliant photos just a pale imitation of those that fill guidebooks and tourist brochures – yet these comprise strong visual memories all the same.

In photographic terms, how do we distinguish between a holiday and travelling? A photographer friend once gave me an interesting description: 'A holiday,' he said, 'is a state of mind; travelling is something of a mission.' Without becoming needlessly philosophical I think that's an apt distinction. A holiday should be a time for relaxation, when family and friends come first. When travelling, you don't need to show such deference and your camera can take more of a front line role.

In fact, there's no reason why your camera shouldn't take a prominent role on holiday, too. You're having fun with the ones you love so it's important to record everything to help all those memories to come flooding back in the future. You just need to ensure your photography doesn't cross that line from becoming a source of cherished memories to something that's a touch invasive and this is something that we'll explore further in this chapter.

56 MASTER CANDID PHOTOGRAPHY

Candid photography has some unwelcome connotations, as it is often associated with invasive, paparazzi-style photography. However I prefer to interpret candid photography as a way to take informal, un-posed shots of your friends and family in an innocuous manner. What are the best ways to capture those totally spontaneous shots?

Well, the key is that the subjects of your candid shots shouldn't be aware that they are being shot. This can mean that you need to be a little furtive, or so bold, that people ignore you. To make sure you are well poised to get the best candid shots whenever there's an opportunity, try these techniques:

Zoom in: This lets you take some great candid shots, but you need to be careful that the distance doesn't create a detachment from the subjects.

Candids: When people are preoccupied they are less likely to be distracted by your camera. This works particularly well for children, especially those who would tend to pull faces at the sight of a camera!

- **Shoot from the hip:** With a camera raised to your eye people will obviously expect you to be taking a photo. Shooting from the hip reduces suspicion and puts people at ease.
- **Use fold-out screens:** If your camera has a fold-out LCD screen you can shoot from the hip with greater precision and certainty, even when looking in a different direction.
- **Find the banana skin:** Some locations and events are ideal for taking some great candid shots, the kind of places where you can almost guarantee fantastic reactions, expressions or poses.
- **Shoot plenty:** Make sure you shoot lots to capture at least one great shot when no one is blinking and the expressions are spot on.
- **Avoid flash:** This is the obvious giveaway that the camera is shooting, and it will probably ruin the atmosphere of your candid shot.
- **Familiarity doesn't breed contempt:** You can shoot more overtly, especially with family and friends, if you have (as you should!) your camera with you all the time. Even the most camera shy will eventually ignore your attentions.
- **Zoom in:** The safe option for capturing candid shots. Standing at a distance and zooming in is perhaps an obvious way to shoot discretely, although it doesn't always provide the best perspective for your subject.

tip

SAFETY AND SUSPICION
Even if you're being candid in your shooting you need to take care that people aren't offended by the presence of a camera. Even more sadly, these days it's not a good idea to shoot kids at play unless those young ones are connected in some way to you. Don't lay your innocent actions open to suspicious minds.

57 MASTER PHOTOGRAPHY IN EXTREME CONDITIONS

Whether your holidays or travels take you to the waters of the Red Sea, the heat of the Wadi Rum, or the sandy beaches of Barcelona, you'll want to collect some great photos of the experience. It's a shame that water, heat and sand don't mix with cameras!

However there's a simple solution: if your camera is not waterproof or dustproof – or you don't trust it to be so – invest in underwater housing. This type of housing can be as economical as a clear plastic bag-type (as popularized by Aquapac) or a more expensive custom job specifically designed for your camera.

Importantly, it will prevent the ingress of anything that can affect the camera and will give you the confidence to shoot in those extreme conditions. With a housing

in place, you can safely expose your camera to hot and dusty conditions (just take care to dust off the lens window in the housing) or you can head underwater with your gear completely intact.

TIPS: SHOOTING UNDERWATER

- **Ensure the housing is secure:** Otherwise it will not be watertight.
- **Keep within maximum depth:** Your underwater housing (or camera, if it's a waterproof one) will come with a recommended depth at which it can be safely used.
- **Get in close to your subjects:** Say within 30cm (12in) if you can, as

seawater can reduce contrast and colour.
- **Use auto white balance:** You can correct any colour casts later.
- **Use wide-angle lens settings:** This will ensure you capture your intended subjects even if the camera is not precisely pointed at them.
- **Shoot within 6m (20ft) of the water surface:** Do this with the sun behind you to achieve best results, but you can also experiment (even at lesser depths) using the camera flash.
- **Stay safe:** Don't get carried away with your photography and ignore everything else going on, and ensure your diving or snorkelling skills are first class.

Underwater: Even a simple camera can achieve great results when used underwater, as long as it is equipped with an appropriate housing. Start with the camera set to Auto Exposure and auto white balance to take some baseline shots; if you need to alter the exposure you may need to surface and reconfigure.

58 DISCOVER THE BEST LOCATION SHOTS

Arriving at a new destination can be alarming for a photographer, as there's so much to see and so much to photograph: landmarks at every turn, exotic scenes and, for good measure, some colourful characters. Where do you turn your camera first? Give in to temptation and fire off some fast shots, but then learn to become a little more considered.

Every day, thousands of tourists round the corner of Paris's Palais de Chaillot and walk across the Esplanade du Trocadero. They are greeted with the breath-taking view down to the Eiffel Tower. Listen carefully and you can hear hundreds of cameras firing, sounding like crickets on a balmy afternoon. As a view this is a classic 'must see', but as a photo it's somewhat unoriginal. But what the heck! It may have been shot millions of times before, but that's because it deserves to be and it shouldn't be missing from your album. After you've taken the classic shot – and perhaps a few more nearby – what should you shoot next?

This is a question you should ask no matter what part of the world you might be in, and the answer is not far away – in fact, it may be in your camera bag or pocket. Guidebooks often include the very best photos of your location; publishers have many thousands of images to choose from and select the very best to give their guide a visual edge. It therefore pays to study guidebooks, holiday brochures and even tourist websites to gain some inspiration. Postcards at the major sites can be another source of inspiration; again only the best will do, so they generally feature the most picturesque views.

Pro tip

GET UP EARLY
Reaching popular locations early can mean shooting them without masses of tourists. This gives you a chance to shoot unhindered at the plum locations with less obstructed views. Personally I don't like tourist places when totally deserted, as there's something unnatural about such shots; I prefer a few people to be around to help provide a sense of scale and place.

△ Guidebooks and postcards: They may not show you the most novel views, but they are great for filling your photo collection with some great ones.

tip

HOP ON A BUS
Tourist and sightseeing buses don't provide the best platforms for shooting photos, but are an ideal way to get your bearings. You can leisurely see what your chosen destination has on offer.

▽Classic or cliché: Some views are so intrinsically characteristic of a location you'd be silly to ignore them. Don't leave it at that, though; explore your subject from different angles and locations. Shooting close up can reveal intriguing structural details, whereas more distant shots put landmarks in context.

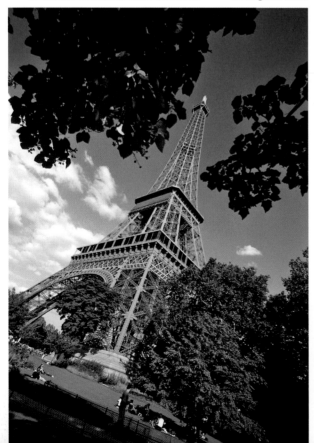

59 USE WEATHER TO ENHANCE YOUR SHOTS

Changes in the weather and the sun's aspect can dramatically affect a scene. In turn, developing an eye for these effects can dramatically boost your photos.

As the sun tracks across the sky, a location and its landmarks can be transformed. Consider the harsh silhouettes created by the sun in a morning scene, then the same scene bathed in the warm light of the afternoon. Changing weather patterns can significantly alter a scene, too. Don't be afraid to revisit locations to take advantage of better – or different – lighting conditions.

A break in the weather: As the clouds broke at the end of the day, a pretty but flatly lit scene was transformed by the salmon pink sky.

Pro tip

EXTREME VIEWS, EXTREME LENSES

Shooting novel views is the perfect excuse to use extreme wide-angle and telephoto lenses (or the equivalent focal lengths on a camera's built-in lens). Normally we would eschew such lenses for architectural work as they risk introducing distortion or allow only a small part of the scene to be recorded, but here that's exactly what we want to do.

60 GO ONE BETTER THAN STOCK SHOTS

Arriving at a photogenic location, even the most artistic and creative of photographers will fire off a few overtly tourist photos; shots taken from those popular vantage points, often marked in guidebooks as 'photo opportunities', and shots taken without the normal concerns for precise composition. These photos may well be a perfect record of the location, but they are often nothing to get excited about.

Of course, there is often a difference between the photos that an experienced or enthusiast photographer might take and those of a casual tourist. The professional photographer's images will be both technically perfect and show subjects in, literally, their best light. So why do the more serious photographers bother with these shots? Often it's because producing high quality images of standard scenic views can make them money in photo libraries as

Millennium Hall: Cardiff's Millennium Hall is a gift of a building for photographers. Clad in copper and with a unique shape, even a standard shot is compelling. Yet move in closer and focus on some of the more extreme surfaces and angles, then you can get some really powerful shots.

Shopping centre: Birmingham's Bullring is one of the city's best photo opportunities but, because of it's unusual organic lines, it is often hard to shoot in its entirety. Close ups of the textured surface, however, produce bold geometric patterns.

these shots are often what editors, travel book publishers and even holiday brochure producers are looking for.

Those photographers, though, will also be looking at other ways of recording buildings and locations, those that are more creative and, perhaps, evocative. Rather than simple and conventional representations, they will aim for something more pictorial. Often this involves getting closer to the subject and shooting from extreme angles. It could also involve shooting at different times of day – night for example, when the look of the building or location is transformed.

The aim of your shot should be to absorb anyone that sees the image; a scenic view that makes them look twice and question what they see. Here are some examples of the conventional view and the more intriguing.

The novel shot: Novel approaches to shooting buildings can lead to views like this that emphasize some of the more extreme elements of a building that, if shot more conventionally, would appear mundane.

61 CAPTURE A SENSE OF PLACE

Which photo best captures the essence of a city: one depicting a landmark, or one showing local residents going about their business? Taking shots that convey a true sense of place involves exploring beyond the tourist trail to gain a fuller understanding of the location and its inhabitants.

It's easy to be seduced by landmarks in a city and to subsequently spend a lot of time shooting them. Hopefully, as well as standard shots, you'll manage to capture some more interesting views of these landmarks, too. However the nature of our world today means that the more popular destinations are so cosmopolitan that you can end up with a collection of photos that comprise only of the tourist image of that location – often complete with tourists.

Gaining a true sense of place involves exploring your location, generally not as part of an organized tourist group. Delve into back streets and older parts of the town, taking in the sights and the smells; the latter will potentially lead you to more interesting sights still. Also consider employing a local guide who can show you places that might be significant to him or her. This guide can also become a bridge between you and the local people, which can allow you to capture some great shots of them as they go about their daily business.

tip

JUXTAPOSITIONS

One of the more interesting ways of capturing a sense of place is to shoot juxtapositions: old and new, wealth and poverty, smart and tacky. Just about every city boasts such combinations and shooting them side-by-side creates interesting – almost reportage style – imagery.

ON YOUR PHONE

Many people tend to feel uneasy when there is a camera around, so use your camera phone to shoot candid shots where a camera might raise more attention. You can also use camera phone apps to give your shots an aged look – a rather overt effect that can benefit some shots, particularly if they are free of tourists.

▷ Aged appearance: Filter apps that give an aged appearance can bring a real sense of mood to your photos.

Old and new: Although many consider old and new buildings to sit incongruously side by side, in fact these juxtapositions can produce strong imagery.

62 LEARN HOW TO SHOOT THE LOCALS

Many of us are reticent to include people in our travel photos for fear of causing offence or getting a negative reaction. So, how should you approach shooting the local inhabitants of your holiday or travel destination?

You can shoot some scenes involving people with impunity: the melee at a busy market or a bustling street scene. People will act with disinterest or just acknowledge you as another tourist shooting a general scene. Move in closer, though, and you'll need to become a bit more judicious in your approach.

What's the best way to shoot people close up? I've always found that it works just to ask them; a few kind words – in their own language – is rarely refused. If you can't manage the local tongue, a gesture with your camera and a nice smile is often just as effective. And if they intimate a 'no', then just smile and move on. Sometimes in foreign countries the simple act of raising a camera to your eye suggests that you would like to photograph people and they will be accommodating, but don't presume.

In some poorer locations people may ask for money to be photographed. Some people feel uneasy with this but, after travelling extensively in areas of India and Africa where this is normal, I have no problem with this scenario. Just think, you'd spend a certain amount of money on a souvenir guidebook packed with other people's photos, so why not invest a little money to shoot your own ones?

⊲△ **People and places:** Shooting images that give a sense of place is about shooting the everyday events such as people as they go about their daily lives, rather than the more sanitized, tourist scenes.

Pro tip

DO YOUR HOMEWORK
It's important to understand where you can and can't photograph when travelling. And the rules can vary not only from country to country, but also from district to district. In some places people are quite happy for you to shoot, say, their places of worship. In a neighbouring area local people may get twitchy if they even see a camera in your hand. And, of course, avoid shooting near sensitive strategic or military installations.

Shooting the locals: When you invite someone to have their photo taken, they will often look straight at the camera rather than adopting a more natural pose. In this case, make the most of the opportunity to shoot some more conventional portrait shots.

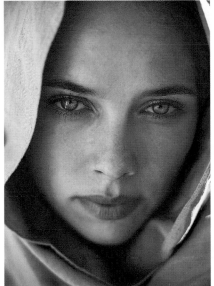

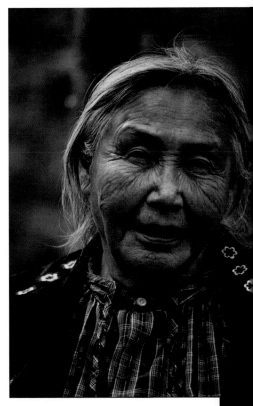

91

63 CAPTURE FAST MOVING ACTION

Many photographers are drawn as spectators to events and subjects when on holiday: motor racing, power boating, air shows, and more. Photographing at these events necessarily demands that you develop and hone your skills in shooting fast moving subjects. Action photography can catch out even some pro photographers, but by adopting different shooting priorities you'll manage to return home with some great action shots.

Many subjects allow us to be considered about our photography. Static – or largely static – scenes give us time to compose and contemplate a shot before finally pressing the shutter. For fast moving subjects there's less time to think and even less time to set the camera. This is why you need to be all set ahead of the event.

Getting the correct exposure is essential. Although Auto, the catch-all exposure mode, will give you reasonable results, it's not best for action photography as it just won't configure your camera with the very best settings. Instead, switch to Shutter Priority mode; this lets you set the shutter speed – essential for freezing action.

In addition, don't be afraid to increase the ISO sensitivity – up to ISO 800 or even ISO 1000 – if this will allow shorter exposure times. Higher ISO speeds result in slightly more grainy – or noisy – images, but this will be compensated by improved sharpness. So, once we have the exposure mode successfully set, what else do we need to do? Here's six more ways to ensure you make the most of any action:

Pro tip

PREDICTING FOCUS
Here's a way to get a guaranteed (well, almost) action shot. Keep an eye on the direction your subject is moving and pre focus the camera at a point a little ahead of the direction of travel. Then release the shutter just as they reach that point.

- **Plan ahead – and know your activity:** The better you get to know the sport or activity you're shooting the better the results will be. Discover where and how the action takes place so you'll be best placed to capture it.
- **Pre-configure your camera:** Fumble around with your camera's controls when shooting and you can almost be assured of missing the key action. Instead, ensure you've set everything to the optimum before the activity begins.
- **Shoot lots – and in bursts:** Take shots in quick succession, scan them later and retain the best. Don't shoot continuously for too long or your camera's memory buffer can fill and you'll have to wait a few seconds for it to clear.

- **Keep your eyes open:** Both eyes, that is. If you are using an optical viewfinder keeping your other eye open lets you track the action and reduces the risk of you losing the subjects in the viewfinder.
- **Don't forget composition:** The best action shots are well composed. A popular way to create a strong composition is to place moving subjects off centre so they appear to move towards the centre of the frame rather than away from it.
- **Follow the action:** Learn to gently pan the camera to follow the action and keep doing so as you release the shutter. This keeps the subject sharp – even at slightly longer shutter times – and blurs the background for dramatic effect.

Composing: Visit a raceway or sports circuit and you'll be guaranteed some great action photo opportunities. Shooting a subject moving towards the centre of the frame, rather than centrally placed or moving away, creates a stronger composition.

ON YOUR PHONE
Camera phones can be a little more sluggish when faced with shooting fast moving objects, but are a great way to shoot short video clips of the action. Again, preconfigure the camera on your phone, setting the zoom to an appropriate telephoto setting so you can fill the screen with the unfolding action.

Framing: It can often be difficult to keep a subject in frame when moving fast and panning the camera, as shown in the inner frame. If this proves the case, zoom out slightly so that you have a greater margin of error in regard to alignment.

Follow Focus: When using Follow Focus mode the camera determines the way the subject is moving and adjusts the focus accordingly. It's remarkably effective – most of the time – but do shoot as much as you can to be sure of a critically sharp shot. Focus becomes more critical when using more powerful (higher magnifying) zoom lenses or zoom settings.

tip

USE ACTION/SPORT OR FOLLOW FOCUS MODES
If your camera doesn't have Shutter Priority mode it may well have an Action or Sports Scene mode. Essentially this does the same thing as Shutter Priority, selecting the fastest possible shutter speed. Many cameras will also offer Follow Focus mode (called Servo AF on some models): here, the camera's focus system will keep locked on to the subject as it moves.

64 HOLIDAY AND TRAVEL PHOTOGRAPHY

While on holiday or travelling, the avid photographer can feel torn between getting some great photos and enjoying the time spent with friends and family. However there's no reason why you cannot do both successfully. Photography can enhance your holiday or travels by allowing you not only to be creative, but also to bring back tangible reminders of some fantastic shared memories.

ESSENTIALS
- As for outdoor photography, aim to capture your destination with some strongly composed shots.
- Capture as much of the local flavour and colour as you can. Unlike in landscape photography, people can often be a great feature in your holiday and travel photos.

TAKE CARE!
- **Put safety first:** Don't explore risky areas and take care in crowded spots. An obvious camera kit bag can attract unwanted attentions.
- **Be mindful of local sensitivities:** Religious, social and political rules may preclude the use of cameras in some situations and locations. Break such rules at your peril!
- **Watch your perspective:** When photographing buildings, watch out for converging verticals. Keep the camera horizontal to keep things square, or point upwards to exaggerate perspective.

EXPOSURE MODES
- **Landscape mode:** Many travel shots are essentially landscapes and as such the Landscape Scene mode will quickly configure your camera appropriately. Watch out for small apertures with low light as this can lead to camera shake.
- **Aperture Priority mode:** Use Aperture Priority mode to let you choose the optimum depth of field according to the subject. When shooting indoors you might need to resort to wide apertures to shoot hand held shots.
- **Auto or Program mode:** Much maligned, nevertheless it can be useful to leave your camera set to these two modes to help capture some spontaneous shots.

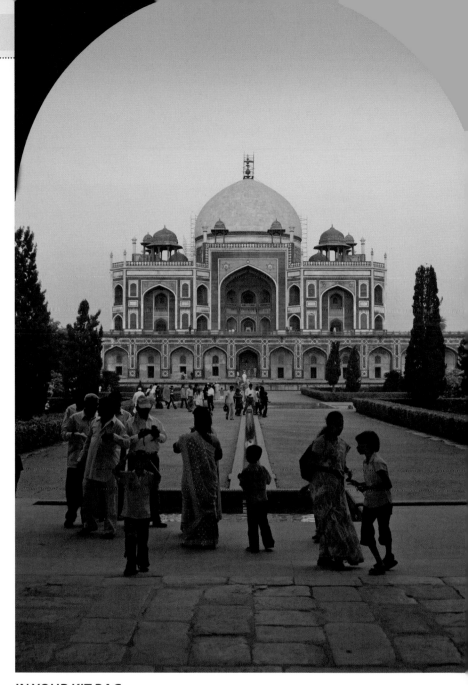

IN YOUR KIT BAG
- **A firm support:** Don't bother with a full tripod when travelling as it will often get in your way and be something of a burden. A table tripod, a GorillaPod or a beanbag will provide essential support when you need to accommodate long exposures.
- **Guidebooks and phone apps:** These are great for exploring new locations and getting you around quickly.
- **Wide and telephoto lenses:** These let you capture tight interiors and zoom in on architectural details. Or, to travel lighter, use a wide ratio zoom lens.

Local colour: Including people in shots can often add to a scene rather than detract from it by adding local colour.

On the tourist trail: Some people are disparaging about tourists, but remember that you are one yourself! Careful repositioning, as here, can capture a scene without other tourists impinging so heavily, or you might just want to include them as an inevitable part of any holiday location scene.

GOOD TO GREAT TIPS

- **Do your research:** Before heading off, read guidebooks and visit websites. Take a look at photos shot for these resources and try to assess where and how they were taken.
- **Pack sensibly:** You may want to pack a lot of kit to cover every eventuality, but doing so can end up restricting your mobility. Think of the bare minimum you might need and then add anything else only if you think it's going to be used.
- **Learn local phrases:** These might help you get some great candid or people shots. If you can't manage phrases, a few words like 'please', 'thank you' and 'may I' can pay enormous dividends when striking up a rapport with local people.
- **Get your bearings:** Hop aboard a sightseeing bus or hire a taxi by the hour so you can begin to absorb the flavour of the location. Also explore the location beyond the tourist trails – with due deference to safety.
- **Take notes:** In a notebook or a voice recorder. It's surprising how quickly you can lose track of where you've been and where you shot images, which can be frustrating if you intend to revisit a scene to shoot under different lighting or weather conditions.
- **Return at different times:** When you find that special photogenic location be prepared to return at different times of the day to shoot it again when the direction and quality of the light has changed. Similarly, note those locations that don't look good on your first visit and consider returning at a different time of day.
- **Approach the locals:** Don't be afraid of talking to local people or asking them if you can photograph them. The worst that can happen is that they say no, and the chances are that you end up with some really memorable shots of interesting people.
- **Shoot lots:** Your visit will be limited in time so don't return home thinking 'if only': 'If only I'd shot some more at the market', 'If only I'd shot that group of dancers'. You don't want to come home with regrets!

Time of day: It's surprising how much difference two or three hours can make to a scene. Here are two shots of the same scene taken in early and late afternoon. The later one (below) is bathed in a much warmer light, making for the more appealing shot.

CHAPTER 6: PHOTOGRAPHING AROUND THE HOME

When you discover how easy it is to take great photos your hobby can suddenly become an obsession; if I can borrow a phrase from that old movie title, 'a magnificent obsession'. You can spend a rapidly increasing amount of your time with a camera in hand as you seek new ways to extend your skills and expand your portfolio. It can be a bit galling then, in the winter months, to find that weather conditions make photography in the great outdoors less appealing. Of course, you should never write off days when the weather is not so good – rain, fog, mist and storms can produce some truly atmospheric photos – but a run of miserable weather can definitely test your patience.

So do you pack up your kit for the year and settle down to read a few photo manuals? Spend some time endlessly manipulating last summer's images? Or do you set about discovering what you can shoot once you've actually shut the front door? Of course, the answer has to be the latter. You may not have access to an expansive landscape indoors, but change your style and pace and you'll discover a whole new world of opportunities – many that you would not be able to find outside. Moreover, indoors you are master of your environment: you can control the lighting and more, helping you to craft precisely defined photos.

In this chapter we'll look at the different ways your home, or indeed any interior, can be used in your photos. This will include the more obvious – shooting more pictorial components – through to the less so – creating abstract still lifes. We'll also look at how easy – but effective – it is to set up a simple home studio for shooting images of treasured objects, whether for your own records and enjoyment, or for getting the best deal if you choose to offer them for sale on auction sites. We won't be too proscribed about shooting just indoors, as we'll also pay the occasional visit to the garden or yard if there's an opportunity for a great photo.

65 BECOME CREATIVE AROUND YOUR HOME

Your camera kit apart, the chances are that you have some prized possessions around your home. This could be in the form of treasured ornaments, cherished collections or perhaps some musical instruments. So why not use them not only to hone your skills when housebound, but also as the subjects of some creative images?

There's no limit to what you could use to get some great shooting experience at home. The only caveat is that whatever objects you shoot should ultimately deliver a powerful image. Your first attempts may well be mediocre; viewed with a critical eye the composition may be poor, perspective and lighting equally so, and the background distracting!

However the great thing about digital photography is that you can view your results instantly and recompose your shots fast. Take a look at the guitar in the photo here: it would be easy to shoot the whole instrument to create a representative yet bland shot. Instead, by zooming in on a section, by creating soft lighting and setting it against a simple background (out of focus, in the manner of conventional portrait photography) the result is considerably more compelling and graphic.

Guitar: The elegant marquetry is perfect for a close up study with your camera. To get the best results, the guitar was carefully lit and shot against a plain background. The camera was mounted on a tripod and positioned across the room, then a modest telephoto setting of f/8 was used to deliver a crisp, sharp image.

Leaves: Close up these leaves take on a more graphic look than if shot with more of the plant included. Here, colour and form dominate the image.

66 GET IN CLOSE FOR ABSTRACT SHOTS

Get yourself and your camera in close to shoot everyday items around the home; you'll find that these subjects can make amazingly abstract forms so their nature is not always obvious in the final image.

Do you recall those quiz games where an everyday item was shot in extreme close up and from an unusual angle? Toothbrushes, kitchen implements and the like all received this treatment then, as the camera drew back, the first person to recognize the image for what it was would win the point. Games and quizzes aside, using familiar objects as the subjects for your photos can produce fascinating results. For the very best results, shoot and enlarge small household items to create stunning poster-size framed prints.

Are there guidelines for this approach? Only some basic ones: make sure your camera is mounted on a tripod so you can get sharp results up close, and so that you can experiment with different apertures. Take care with the lighting, too; although macro settings on many cameras allow you to move in really close, the proximity of the front of the lens can put the subject in shadow.

Close up: A section of crystal on a kitchen work surface might seem an unlikely subject for graphic photos, but when shot close up using a camera's Macro mode it takes on a whole different appearance. A successful shot comes from keeping the camera parallel with the surface and providing even lighting.

Abstract: This image came from my desk: the back of an old computer provides the subject for a bold abstract.

Pro tip

KEEP IT CLEAN
Dust free, that is. When you are shooting in extreme close up and/or you're using bright light sources, traces of dust on surfaces can be shown up in sharp relief. Before you shoot, make sure you give everything a thorough dusting or, better still, a vacuum, followed by a careful clean with a microporous cloth.

67 CREATE A VALUABLE RECORD OF YOUR HOME

You may not use the results as wall hangings or as part of your portfolio, but good photos of your home can be very valuable indeed – should the worst happen.

Whether your home is a showpiece of contemporary interior design or something more clearly lived in, there's good reason to shoot the interior from every angle. Should you suffer some loss – whether by theft, fire or water damage – you'll need to provide an inventory of what was lost, often along with clear evidence of the inventoried items being in your possession. A set of photos recording your home provides the perfect visual record.

Rather than shooting off some casual shots, it's a much better idea to use your photo skills to create really good ones that can leave no room for doubt about the items. Shoot well exposed images with a tripod, square on to each wall, as well as close up details to ensure that everything is covered. Then file your images away, at home and somewhere else safe; it's a good idea to keep a copy at a family member's house or even in a filing cabinet at work.

Home interiors: When shooting details of a home interior you can control the lighting to get the shots just right. Don't be afraid to mix room lighting and flash – with the camera's white balance set to Auto you'll get great results just about every time

68 SHOOT STRIKING PHOTOS OF YOUR VALUABLES

Valuable and treasured objects are ideal subjects for photography. Beautiful objects, though, need to be shot in a way that truly reflects their striking features.

Getting the best photos of your valuables demands good preparation, otherwise they will neither show off the objects' virtues nor be in any way pictorial. Few of us can set up a full photo studio in our own homes, but we can set up something a little more rudimentary that provides an ideal setting for our shots. Great shots of our treasures should be simply that: photos of those objects. This is not about including a contrasting background or any other creative distractions.

An easy way to create a simple background for this type of photo is to obtain a large sheet of white paper, for example A1 (33½ x 33in) size, from your local art store. Attach one edge to a wall, then allow it to drape over a desk – the gentle curve provides you with a shadow-free

setting. Now position a pair of desk lamps either side to light the scene. To maintain colour fidelity, use the camera's white balance control set to manual so that the scene will be recorded white, no matter what lighting you use.

You can now place your subjects on the paper, adjusting the lighting to avoid undue shadows. Mount your camera on a tripod in front of the scene then shoot. Check your shot and if it doesn't look good, reconfigure the subject's position and lighting until it does. Don't forget you can also perk up your shots using image manipulation software.

Pro tip

USE A TABLETOP STUDIO
If you have a large number of objects to photograph, or intend to do this on a regular basis, it can be worth investing in a tabletop studio. This comprises of a small light tent that diffuses light from the supplied sources to minimize shadows, along with a selection of collapsible backdrops that can be stowed away when not needed.

Treasured items: The key to good results is to avoid shadows and bright reflections by using diffused lighting from multiple – at least two – sources.

Tabletop studio: Perfect for when you want to shoot lots of objects using controllable conditions.

69 SHOOT BETTER AUCTION SITE PHOTOS

When you sell items on an auction site you'll want to get the best price for them, something that may not happen if you don't make your sale item images as appealing as possible.

OK, so a picture isn't everything, but it can give you a good advantage. So often mediocre photos lead to disputes when the seller's description is not matched by the buyers' expectation. A high quality image can avoid such disputes and garner a greater number of interested buyers.

Key to producing great auction site photos is to give your product shots the same attention as you might, say, a portrait shot of a family member, or the photo of a treasured item that you want to show off. However you also need to go beyond that to also include shots that make your product unique.

For example, if your item really is brand new, show this in your photos. Make it clear that there are none of the wear marks that might characterize something that is not in pristine condition through use. Similarly, if there is any damage, be sure to show that. Disputes about descriptions of damage

happen frequently, yet a simple shot can avoid any ambiguity. Here are a few more tips:

- **Do:** Use a tripod as it will let you compose your shot well, and let you review your image to repeat if necessary.
- **Do:** Check the colours of your sale item in the images and adjust (using white balance controls, or software manipulation) to ensure they are authentic.
- **Do:** Use a white or neutral background (a wall or a sheet) to avoid any colour casts and to focus attention on the sale object.
- **Do:** Add something to provide a sense of scale if photographing a statue, curio or jewellery – again to avoid any misunderstandings.
- **Do:** Shoot small objects close up and with a small lens aperture to ensure sufficient depth of field.
- **Do:** Take some extra shots of product details such as a serial number panel or unique details, not necessarily to include on the auction site, but to provide quickly to interested buyers should they request this information.
- **Don't:** Include anything you are not selling. Even if you mention something is not for sale in the description, photos of non-sale objects can lead to disputes.
- **Don't:** Use daylight as this doesn't give good, even lighting. Instead try using a couple of table lamps for effective, shadowless lighting.

Auction photos: If your sale item has identifying marks – such as signatures on photographs and paintings or certificates of authenticity – make sure you grab good shots of these too.

70 CREATE MEMORABLE SHOTS OF BOUQUETS

A bouquet of flowers, whether to celebrate a special occasion or simply to brighten up the home, is always a cheery sight. However photos of them, taken as a keepsake, often result in rather prosaic shots. Employ a little more thought, though, and you can turn a collection of bright blooms into a collection of colourful, romantic and abstract images that you can enjoy long after the flowers themselves are gone.

Instead try these ideas to achieve more powerful images:

- **Get in close:** Fill the frame with the colourful blooms. Pick a more obvious or bold bloom to be the subject and position in the frame accordingly.
- **Apply a soft focus effect:** A soft focus effect (see Use a camera filter to create a soft, romantic portrait and Use software to create a soft, romantic portrait) creates a dreamy, romantic image and works particularly well with flowers that have soft pastel colours.
- **Soft focus:** An ethereal romantic look is (almost) guaranteed if you apply a modest amount of soft focus.
- **Get in really close:** Select a single bloom and get up close – or use a macro lens – to record the fine details of the petals and stamens. Choose a large sculptural bloom such as a large lily for this; the shape of these flowers will produce simple but intriguing results.

Close up: Filling the frame with blooms, with a strong central focus, produces a shot that just bursts with colour and says summer.

Pro tip

ARRANGE YOUR BOUQUET
When you shoot flowers, don't just dump them in a vase and hope for the best. Style your flowers so they make an attractive arrangement. Flower arranging is a skilled art, but with a little vision you can at least produce a display suitable for getting some great shots.

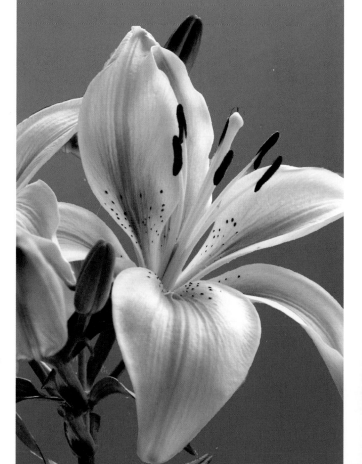

ON YOUR PHONE
Use soft focus effect apps on your camera phone to produce an image similar to that shown above, ideal for sending as a photo message to a loved one. Alternatively, why not try applying some monochrome effects? Stripping away the mix of colours produces an image where the shape and form take centre stage.

Really close: A study of a single bloom is perfect for creating a bold, graphic image. Like portraits, shots like this work best with a simple background like a painted wall, as used here.

71 BECOME CREATIVE WITH FLOWERS AND LEAVES

Create even more interesting shots of flowers – or, indeed, anything – by shooting them from unusual angles and using lighting in more creative ways.

Conventionally we shoot and light flowers and floral displays from the front as this approach works best with the colours and the displays. However this is not the only way: try shooting delicate petals lit from behind. Sunlight shining through an open window, or shining from a low angle in the garden, will illuminate translucent petals and create a more delicate effect compared to the conventional front-lit shot.

Go one step further and shoot blooms from below; this will further emphasize the translucent petals and position the flower heads at an interesting angle in the shot. This effect works best with simple flowers – such as daisies, sweet peas and some chrysanthemums – but experiment with any blooms you find. When the sun is low, particularly in autumn, backlit leaves can also create vibrant displays.

Low angles: Crouch down low and shoot flower heads from the underside to get vibrant colours from translucent petals.

Autumn leaves: Backlit leaves in autumn hues can produce strong images – either when shooting a whole tree, as here, or in close up.

Back lighting: Backlit blooms produce delicate colours and can reveal the equally delicate structure of the plant. A simple, dark background is best to display backlit planting.

Raised view: For some subjects a raised view is quite acceptable. As mentioned, thinking of yourself as a camera-equipped model in the scene will help you to determine correct perspective.

Good: Shooting from a raised perspective shows the entire scene, but we as viewers are not involved or included in the scene, which we would be were this scene 'for real'. And watch that focus!

Great: Getting down low – as if we were a character in this miniature world – provides a more realistic perspective. Unless you are deliberately attempting to emulate a conventional-style portrait with a subject isolated from the surroundings, use a small aperture – f/11 or smaller – to ensure the whole scene is in sharp focus.

72 SHOOT REALISTIC TABLETOP SCENES

Photographers can be a bit obsessive about taking photos, yet many also have other hobbies and interests – and if they don't, they have family members or friends that do. Many popular interests, including model railways, doll's house building and battle scene recreations, involve tabletop-style tableaux that are great fun to photograph, but all too easy to photograph badly.

Not being an aficionado, I am constantly impressed by the level of detail devotees of model making achieve. Whether it is a doll's house or a recreation of the Somerset and Dorset Railway in its heyday, the attention to detail is verging on the fanatical. So, when we come to photograph these scenes we need to show consideration to the work that has gone into them and shoot in a way that makes them appear to be the real thing – in everything but scale. It can be useful to imagine that you're a character in the scene and you have a teeny camera. How would the scene look? What camera angles would you use?

Now get shooting! Your first shots, assuming you've metaphorically put yourself in the scene, will be pretty good, but there will probably be a couple of points that will betray the small-scale nature of the shots. The first is the depth of field, which is very shallow when shooting close up and close in, so you need to force your camera – using the aperture control – to select the smallest possible setting. Then, as in a life-sized landscape, focus about one-third of the way towards the most distant part of the scene, which will produce the greatest depth of field for a given aperture.

The second point that will betray the small scale is the environment of the model. When you take a look at a scene – whether it's a railway, a recreation of the Battle of Waterloo, or a recreation of Downton Abbey in miniature – you don't pay much attention to the environs. Yet the camera is not so discriminating; it will show everything. So for authenticity you will need to make sure that there is a good background – or if not, that you've covered up anything that might cause a distraction. And don't forget to check – and modify if necessary – the lighting on your scenes to achieve the greatest authenticity.

73 SHOOT BETTER STILL LIFE PHOTOS

Painters were rather fond of depicting still life scenes. Unlike portraits the subjects did not move or need paying, and unlike landscapes, the subject was not at the whim of the weather. For photographers, too, shooting still lifes can be a great way to hone your composition and lighting skills.

Phone filters: Filter apps on your phone can help bring an aged look to your still life shots.

Time is on your side when composing still life shots so go slowly and take the time you need to adjust all the elements of your shot including:

- **The right subject:** Choose compatible (or contrasting) subjects.
- **Less is often more:** Don't over guild that lily with additional, unnecessary props.
- **A good backdrop:** If the background is not a direct part of the still life.
- **Effective lighting:** Use light and shade to add or suppress depth.

- **Post production:** Consider whether the shot will benefit from some digital manipulation.

ON YOUR PHONE
The nature of still life shots means that many lend themselves to the special effects that you can apply on your camera phone. Try using filters like Hipstamatic to produce grainy, aged results.

Cliché: Play around with objects and try to be imaginative so you avoid clichés like this shot of a rose and teacup.

Large scale: Still life shots need not be confined to tabletops; larger scale settings can also be very effective.

74 MASTER MACRO PHOTOGRAPHY

Coins, stamps, historic banknotes and even small figurines are miniature works of art. Record them effectively and help reflect their true beauty and elegance by mastering the art of macro photography.

When dealing with flat subjects, or those with a flat surface such as stamps, ephemera or coins, it's crucial that you shoot squarely from a point over the centre of the subject. If you take a shot from a slightly oblique angle, you won't get a sharp image. Moreover in extreme close up, circular subjects will quickly distort into ovals.

The ideal way to take macro and close up shots of flat objects is to use a tripod. With this kit you can accurately angle your camera to face the subjects square on, and you'll be able to adjust the lighting – using simple table lamps, for example – to brightly and evenly illuminate the subject. For subjects with some surface relief, such as coins, a little directional light helps to improve the appearance of their texture by enhancing the shadows.

How best to display your objects? Simply is usually the answer to this: a plain background is often preferable to something more cluttered. But also think about where you intend to use the images. If they are purely for record, a white background will suffice. However if you have a more elaborate use in mind, you may want to enhance the subject with a background that complements the subject's shape and theme.

WATCH OUT!

Accidentally shooting a reflection of the camera and photographer can be a problem whenever you shoot polished surfaces, but this is compounded when you shoot coins and other polished metals. Avoid this by moving slightly off axis – with an emphasis on slightly, so as not to contradict what was said above – or, if possible, by concentrating the lighting on the subject, thus keeping you and your camera in relative darkness.

Pro tip

USE MACRO LENSES
If you find macro photography is your forte it could be worth investing in a special macro lens. Although these lenses can also be used for general shooting duties, their optical configuration is precisely optimized for shooting macro subjects.

Accurate display: You need to be square on and perpendicular to your subjects (right). Move off axis slightly and the result can be distortion to the shape and loss of focus in parts of the subject.

Appropriate display: Plain backgrounds are perfect for simple record shots, perhaps for your insurance records, but if you want to show the subject as a work of art, something more complementary may be called for.

Unwanted reflections: Sharp and well exposed, but look beyond the coins and you'll see a dark representation of the photographer, his camera and even, if you look closely, his watch.

Depth of field: Adjust the aperture to control the depth of field, which will either isolate the subject in the shot or reveal more of the surroundings.

75 MASTER THREE-DIMENSIONAL MACRO WORK

The basics of macro photography apply whether your objects are flat or three-dimensional. However if your subject has depth, you'll also need to be critical with the aperture setting to control what is kept in sharp focus.

Rather like in portrait photography where it is crucial that you focus on the eyes, in close up photography you need to assess what is the equivalent to the eyes, and focus on that. It may be the tip of a stamen on a flower, or the head of a dragonfly. You must then determine whether you want more of the subject (and the scene) in focus or less, increasing or decreasing the aperture respectively.

Altering the aperture – and consequently the depth of field – will also have a bearing on the background. With a wide aperture your subject will be sharp in front of a blurred background, ideal for isolating and displaying the subject in its purest form. With a smaller aperture your subject and background risk becoming confused, though it can sometimes be a good idea to show a subject in its widest context.

Honey bee: It can be easy to get in close to a honey bee while it is concentrating on gathering nectar to capture an impressive macro shot. Just watch that the camera doesn't cast a shadow on the scene.

tip

HAND HELD SHOTS
When shooting moving subjects – insects or flower parts blowing in the wind – it can be more effective to hand hold your shots. Preconfigure the camera's aperture setting and set a reasonably high ISO sensitivity, say ISO 800, for short exposures – then shoot lots of images to guarantee some sharp ones.

76 PHOTOGRAPHY AROUND THE HOME

It is perhaps a little surprising, but even though cameras today are rather competent across a wide range of shooting situations, most of us pack them away at home. This is a shame, because many interiors – whether our own homes or public buildings – offer great opportunities and are a perfect place to shoot when the weather outside is dreary. And there are plenty of photo opportunities in our gardens and grounds, too.

ESSENTIALS
- When shooting with a wide-angle lens inside, keep the camera level to avoid distortions.
- Alternatively, apply a very obvious tilt if you want to exaggerate these distortions for dramatic effect – if you want to enhance the feeling of height, for example.

TAKE CARE!
- **Watch out for extreme contrast:** Between a dimly lit interior and brighter windows, for example. Turn on interior lights or use flash to reduce the contrast range; if there is still a wide range of brightness, slightly underexpose the interior to ensure brighter areas are better exposed. You can correct the underexposure later more effectively than you can overexposed areas.

EXPOSURE MODES
- **Aperture Priority mode:** Set a small aperture – say f/8 to f/16 – as you'll normally want everything in the scene to be in sharp focus.
- **Manual mode:** If you're faced with a range of brightness levels you may find it easier to set the exposure manually, or to set a degree of exposure compensation.

IN YOUR KIT BAG
- **Wide-angle lenses:** Essential for getting great shots of interior spaces – and general views in confined garden spaces.
- **Wide aperture prime (non-zoom) lenses:** Great for situations where the light levels are really low.
- **Tripod or other firm support:** With your camera mounted on a tripod, it's easier to check that you've set it square on to interior spaces to help overcome distortions.
- **External (bounce) flash:** Provides omnidirectional lighting for interior spaces. It can also help outdoors (without bounce) to augment any available daylight.

GOOD TO GREAT TIPS
- **Go for the wide view:** Use wide-angle lenses for shooting building interiors. It's perhaps stating the obvious, but you'll fit more in your

Balancing brightness: Windows, even when the weather is dull, can end up over bright in our images. Even things up by ramping up the lighting inside – or avoid including them in the shot.

shot, which is perfect for successful architectural interiors. Wide-angle lenses also make it easier to keep more of the scene in sharp focus at a given aperture.

- **Go for details in the garden:** A wide view outdoors can result in that confused 'pot pourri' effect, with too many clashing colours and shapes. Move or zoom in to capture details instead.
- **Use flash with care:** If you want or need to use flash, don't use direct flash. You'll end up with a bright (or over bright) foreground and dark background. Use bounce flash instead – you'll get more even results. You don't have bounce flash? Position the camera on a tripod and use a longer exposure.
- **Make use of ambient lighting:** Don't be afraid to turn on the lighting in a room. It will increase the lighting levels and can sometimes be useful if the light streaming through the

windows is too bright and difficult to balance with the interior.
- **Set the white balance:** You'll be okay on auto white balance most of the time, but for better results with artificial lighting, try switching to an alternate setting.
- **Rules are rules:** Not a problem at home, but photography is restricted in some interior and exterior locations. Sometimes for security reasons, sometimes to prevent damage (imagine the cumulative effect of the light from millions of flash photos every year) and sometimes out of pure perversity. Do follow the rules; I've known photographers who have had their memory cards wiped, complete with many legal images, just because they took a single shot in a restricted area.
- **Consider HDR techniques:** If there is a wide range of brightness in the room, consider using HDR

techniques to accommodate all light levels successfully (see Control extreme contrasts with HDR).
- **Steal ideas from estate agents and realtors:** These people are in the business of making the interiors of even the most modest of properties look saleable. Go online and look at the way in which they represent properties. They tend to make good use of wide-angle lenses to make rooms appear larger, as well as good lighting. Also look at how they present the garden and grounds in their photos, often using these to complement the homes themselves.

HDR: HDR techniques are ideal when brightness ranges are too extreme to accommodate with any other means. Everything from the dark corners to the brightly lit sky becomes better defined.

CHAPTER 7: SHOOTING NIGHT AND LOW LIGHT PHOTOGRAPHY

It's surprising – or perhaps it isn't – that the Program and Auto Exposure modes of cameras are accurately configured to deliver great results only in what are considered to be 'normal' conditions. Camera manufacturers' definitions of normal are the same as that of many photographers: daytime scenes with a moderate to high level of lighting.

Of course, if we were to do some sort of quantitative analysis – which indeed is what camera makers do – we would find that the vast majority of photographs are shot under these conditions. Indeed, the majority of photographs we have looked at and discussed in this book would qualify. However as your photographic skills develop, you'll begin to notice that this exposure profile gives precise results only in a fairly narrow band of conditions.

For example, under similar light levels a shot of a family picnic in a meadow, and the same scene shot on a sandy beach, would produce different results if the camera were set to Auto Exposure mode. This is because the latter beach scene, by virtue of the greater amount of reflected light, would be darker; in a snowfield (perhaps not the best place for a picnic!) the result would be even more extreme.

To achieve great results no matter what the conditions, we use exposure compensation to tweak the aperture – or the exposure time – as the conditions become more extreme so that our exposures remain correct. In this section we'll look at exactly how to do this, by understanding more about the camera and the way it produces images. In particular, we'll be examining situations where light levels are low and our cameras need coaxing to deliver images that not only faithfully reproduce scenes, but also can actually enhance them.

77 SET YOUR CAMERA FOR LOW LIGHT

There's nothing difficult about shooting in low light conditions – whether they be a gloomy day, an interior or even a night view. You just need to ensure that your camera is properly set up not only to record the physicality of the scene, but also to record accurate light levels and colour rendition.

There's still a certain reticence with photographers to shoot photos when the light levels are low. There's a good reason for this: back in the days when cameras used film, shooting was ultimately limited by the scope of the film sensitivity. In general, film tended to cater for the mass market with products suitable for bright daylight; using this in low light conditions would involve long exposure times and could produce unwelcome colour casts.

Now with digital cameras, when the light levels fall you can up the camera's ISO sensitivity to compensate. There are drawbacks to this – increasing sensitivity too much can produce grainy, noisy images – but as a rule low light conditions need no longer be seen as a hindrance to great photography. In fact, quite the reverse: dim conditions can often produce extremely powerful, evocative images.

When setting your camera for shooting in the dark don't be afraid to use ISO settings of 800, 1000 or even higher. Pay attention to the exposure time: if you are hand holding your camera, ensure that the shutter speeds are comparatively short, faster than $1/60$ second in standard or wide-angle settings, then progressively faster for telephoto settings. It's better to increase the ISO sensitivity and risk a touch of noise in your shot than to shoot something unsharp.

tip

THE IMPORTANCE OF SHARP SHOOTING

Even with a high ISO sensitivity, low light exposures tend to be longer than those in brighter conditions. This means camera shake is a risk and will render an image soft and not critically sharp. Turn on vibration reduction if available, or use a firm support. A tripod is the most versatile support available, but a monopod, a GorillaPod or even an impromptu support – a wall, post or chair back – can make a visible difference.

Sharp images: Sharpness is critical in any photo. A pocketable support such as this GorillaPod is versatile and can make all the difference to image quality.

WATCH OUT!

As a rule, exposure metering systems are designed for normal daylight shots, and don't recognize when you are trying to shoot a scene in dim light. The result will be overexposure, totally destroying any mood. Ensure you preserve this mood by deliberately underexposing: use the exposure compensation control to underexpose by -1, -2, or even more stops. Check your shots on the camera's LCD screen to assess whether the setting is appropriate.

Dark mood: Controlling the exposure is essential to preserve the dark tones in a scene (far right).

78 USE YOUR CAMERA'S NIGHT MODES

Many cameras feature night exposure modes that can automatically configure your camera to get the best results at night and in very dim conditions. These are excellent shortcuts, ideal when you need to quickly take shots in difficult situations. Night Portrait and Night Scene are the most common of these night exposure modes.

In Night Portrait mode, the camera will take an accurately exposed portrait shot of subjects at night against equally well exposed city backgrounds. How does it do this? By setting a long exposure suitable for accurately recording the dark background scene, but combining this with a burst of flash light from the flashgun to correctly expose the subjects – so a tripod or firm support is needed. This mode is ideal for tourist style shots of people standing in front of floodlit buildings and cityscapes.

The Night Scene mode is essentially the same except there's no flash. Use this – with the camera mounted on a tripod, or resting on a firm support – to record cityscapes or floodlit buildings at night. The exposure will be carefully controlled to maintain the dark tones that are essential to a night look.

Night Scene: Shoot perfect night scenes using the camera's Night Scene mode. In busy or popular places it's often impossible (or not permitted) to use a tripod to keep the camera steady, so for this shot the camera was propped on a conveniently placed handrail. Shooting in the late twilight (rather than night time) allows the sky to be represented in deep blue rather than featureless black, adding to the depth and pictorial value of the scene.

79 ADJUST YOUR APERTURE AFTER DARK

By understanding how the aperture can affect scenes after dark we can achieve more control over the way our images look.

When faced with dimly lit scenes – whether after dark, in gloomy weather or indoors – there's a natural tendency to direct as much light into the camera as possible. We can do that in three ways: by cranking up the ISO sensitivity, by extending the exposure time, or by increasing the aperture – alternatively, by employing a combination of the three.

Often it's the aperture we adjust, worried that increasing the sensitivity will add to the digital noise in the image and using long exposures will demand a firm mounting for the camera. So, increasing the aperture is seen as the least damaging solution, right? To a point yes, but altering the aperture does have an effect, over and beyond the obvious one of affecting depth of field.

Using a large aperture can cause bright light sources and reflections to become extended smudges of light. The degree to which this occurs will depend on the lens, but zoom lenses – with more lens elements – are more prone to cause the effect. However select a smaller aperture and you'll get more sharply defined lights and – which is what makes small apertures so valuable – each becomes an attractive multipoint star.

Wide aperture: With a wide aperture selected (f/4) the streetlights in this scene are rendered as unattractive blobs of light.

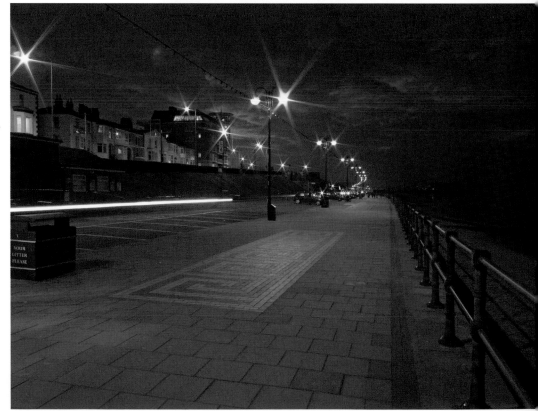

Small aperture: Switching to a smaller aperture (f/11), the lights are rendered as more attractive stars; reducing the aperture further would produce even better defined stars.

80 ALTER YOUR SHUTTER SPEED AFTER DARK

Altering the shutter speed when shooting after dark can also be used for creative effects, enhancing – or making obvious – the movement in a shot.

Speeding train: In this bracketed exposure an underground train has been shot using ambient lighting at ¼ second, ½ second and 1 second.

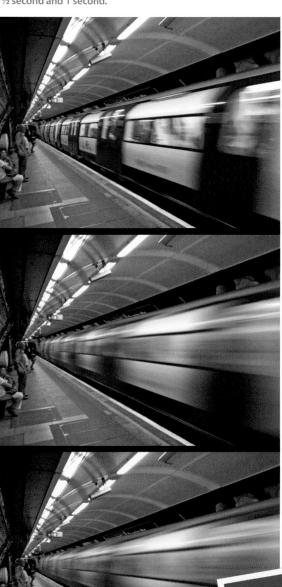

If you looked closely at the two images that were taken at different apertures in Adjust your aperture after dark, you may have spotted another difference between them; one that was for our purposes in those examples neither significant nor intended. In the first shot we recorded images of cars on the roadway; in the second, only long light trails.

During the exposure – which lasted for some 4 seconds – the cars moved along the road. They were not sufficiently slow to be recorded, but their much brighter head and taillights were. On this premise we can employ varied exposure times to produce a range of creative – or compositional – effects in our shots after dark:

- **Use very long exposures:** To remove people from a scene (up to 30 seconds). People walking will not be recorded, or not visibly recorded.
- **Use long exposures:** To record people as ethereal ghost-like images (1 to 2 seconds).
- **Use moderately long exposures:** To enhance the sense of speed through creative blurring (½ second or longer).
- **Create ribbons of light on roadways:** By using moderately long exposures to record passing traffic (up to 30 seconds).
- **Give flowing water and waterfalls a silken appearance:** By using long exposures (4 seconds or longer).

WATCH OUT!

When altering shutter speed, you will need to alter the aperture and/or the ISO sensitivity to maintain the correct exposure. Double check the results when doing so to ensure that any changes you have made to the aperture or sensitivity have not compromised the image in any way – altering depth of field, fineness of light sources or introducing digital noise.

The Grand Canal: Compared with the short, ¼ second exposure (inset), in the longer, 4 second exposure the boats become trails and the water takes on a softer, more silken appearance. The required smaller aperture has also given bright lights a characteristic look that resembles stars.

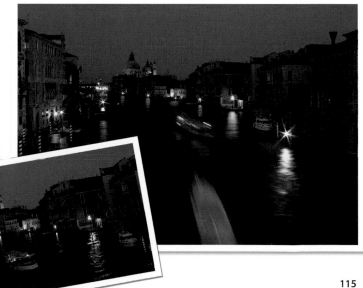

81 SHOOT WINTER LIGHTS – OUTDOORS

In winter our villages, towns and cities are transformed by coloured lights, winter shop displays and winter markets. Make sure you exploit these fantastic transformations by focusing on the bright colours and shapes they provide, which are so characteristic of this time of year.

As autumn gives way to winter our familiar, and often monochrome, townscapes and cityscapes are transformed. With worse weather and shorter hours of daylight, coloured lights and lively sculptural decorations bring a brief and welcome respite. They also provide an excellent opportunity for extending our outdoor photography season.

In the Northern Hemisphere, where the festive season is in full swing, you will find much to shoot – from municipal Christmas trees to upscale store window displays that vie to outdo each other as they attempt to attract the passing shoppers. And don't forget the Santa's Grottos that pop up in city centres and shopping malls.

There are two bits of advice for getting the best from winter lights. First, watch your exposures: don't shoot with long exposures, as you'll lose the colour and subtlety of displays. Instead, shoot at $1/60$ second at f/5.6 ISO 200 to get a baseline exposure then vary accordingly. Alternatively, set your camera to Auto or Program mode with an exposure compensation of -2 stops.

The second bit of advice, applicable for achieving great results when shooting any cityscape at night, is to work in the evening when there is still a little residual light in the sky, rather than in the total dark of later. By doing this, you'll capture more depth as well as more interesting forms in the shot.

Winter markets: They may be an interesting addition to the city but German market-style chalets aren't necessarily that picturesque. In fact, shot from this angle, they are nothing more than a shed!

Winter gifts: The goods for sale inside market stalls, conversely, are both interesting and colourful. Although interesting individually, these goods produce intriguing patterns when shot in groups.

Window displays: You probably wouldn't give a shop window display a second glance much of the year, but as the festive season approaches many put on their best finery and are ideal for capturing some attractive, slightly abstract shots.

82 SHOOT WINTER LIGHTS – INDOORS

Whether for Christmas, Diwali, or just to brighten the gloom, many houses become a riot of fairy lights and sparkling decorations as winter deepens.

Indoors, you may want to photograph your decorations to show off your decorative skills, to use as the basis of greetings cards, or to help remember an important time of year. And as there are often extended holidays at this time of year, it's also a great time to spend honing your photographic skills.

You can treat many decorations as still lifes, altering and refining the displays to produce the best shots. You can also play with the lighting: this time of year you won't just have conventional lighting to use, but also decorative lights, fairy lights and even candles to add warm lighting to the scenes.

Abstract lights: Set the camera's focus to an extreme (close up or infinity) and shoot a bundle of fairy lights to create some bold, abstract images. You can also underexpose to enhance colour.

Decorations: Decorative items can be arranged to produce still life collections. Play around with the combinations and use different apertures to control the depth of field – from shallow, concentrating on one decoration, through to deep, where all will be in focus.

Trees: Close ups of decorated trees can make great shots – and are often more pictorial than shots of the whole tree. You will need to balance the lighting between the lights on the tree and ambient lighting for best effect. Also avoid flash, as it tends to wash out the tree lights and will create a very flat illumination.

Small apertures: Selecting a small aperture, say f/16, will produce star-like effects from small tree lights and fairy lights (see Adjust your aperture after dark).

WATCH OUT!

Reflective glass baubles are a staple of many decoration schemes, but beware – it's easy, as here, to catch a reflection of the camera and photographer in the shot if you get too close. Shoot instead from a distance using the camera's zoom lens; you'll still get a reflection but it will be small and less distinct.

Glass baubles: Watch out for those unwanted reflections!

83 MAINTAIN THE TRUE COLOURS OF SUNSET

If we were to rank disappointing photos by subject, I'd have no doubt that sunrises and sunsets would feature in the top five. Sunsets (here we'll use this to cover sunrises, too) are one of those subjects that colour photography was made for. True, many sunsets are dull, but shoot a good one and you capture a riot of colour – and often you don't need to travel too far to capture one!

So why do so many sunset shots lead to disappointment? It comes down to the camera. Despite all the advanced technical wizardry built in to even the most diminutive of models, cameras don't recognize sunsets for what they are.

The abundance of warm colours reds, oranges, pinks and yellows – fools the camera's white balance, which is instead expecting a more mixed palette of colours. The result is weak colours that do not reflect the exuberance of the actual sunset.

How to we keep the colours on target? One way is to boost and adjust the colours in post production. Yet I always feel this is a bit of a cheat; I'd rather capture the colours in camera. So here are some simple ways to help you preserve the original colour and mood:

- **Underexpose:** Set the exposure compensation control on your camera to -1 stop. You'll get deeper, richer colours at a stroke, though any foreground detail might be lost.
- **Use a graduated filter:** This can hold back the brightness of the sunset by underexposing it slightly, but will retain the foreground detail (see Expose landscapes with graduated filters).
- **Use Sunset Scene mode:** Most cameras have a similar setting that overrides the camera's normal white balance settings and skews them towards the warmer colours. It will also increase the colour saturation.

You don't necessarily need to use all three techniques – you can go too far with your colour enhancement. Keep checking the image on your camera's review LCD screen to test the effects and compensate as needed.

Twilight colour: Once the sun has set the sunset colours don't disappear. There's often a period in early twilight when the colours can become even more powerful; at the same time, we can now shoot without the extreme contrasts of the sunset itself.

tip

WHEN THE SUN DISAPPEARS
Sunsets don't end when the sun goes down; you'll still get some powerful sunset colours when the sun has disappeared behind the horizon – and, conversely, before the morning sun has risen – so don't disappear too swiftly. Neither do you need to include the sun as part of the shot; oblique views can work just as well.

Sunsets: The first image is the straight shot; it isn't bad, but not as colourful as the sunset actually was. In the second, switching to Sunset Scene mode adds a little more colour. Finally in the third, a graduated filter has been added; this reduces the contrast in the scene, slightly underexposing the sky and lightening the foreground to create the best shot.

84 CATCH SUNSET COLOURS ON THE LANDSCAPE

It's easy to be seduced as a vibrant sunset plays out before you and to focus on it. But take a look behind you. All those bright colours in the sky are casting their warm tones over the landscape. Turn around and get some shots of these transient colours, too.

The colours of the sunlit sky during sunset or sunrise – when the sky itself is not visible – tend to be reflected around the landscape and will illuminate the surroundings. This light does tend to be faint, sometimes so faint that our eyes struggle to see it. Use your camera to capture this colour and to intensify it by shooting with slight underexposure.

Warm glow: The colours of a sunset cast a warm glow on the landscape that may be present for just a few minutes, so make the most of it.

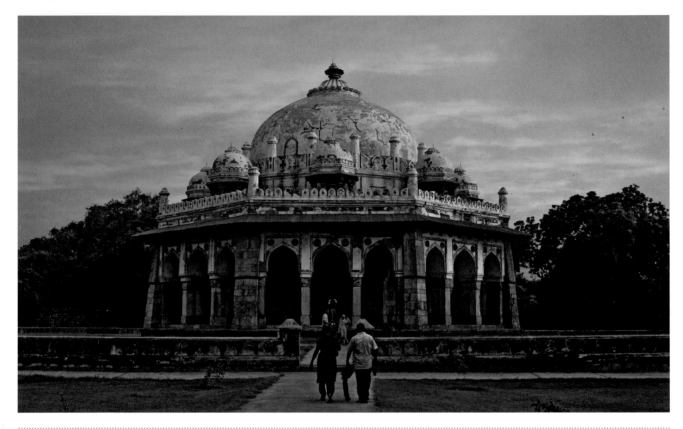

85 SHOOT IMPRESSIVE INTERIORS

Don't limit yourself to shooting outdoor scenes in low light. Buildings such as churches, cathedrals, temples and grand civic structures have photogenic interiors that can provide some great low light shots – and the same rules of low light photography apply.

To get the best results use wide-angle lenses so you can capture as much of the interior as possible. With a wide-angle lens you can also hand hold the camera for longer exposures than when using lenses with longer focal lengths – perfect where tripods are banned. Brace yourself and/or your camera to help get even sharper results.

Watch out for where light from the outside comes through – either at windows or other apertures – as this can affect exposures. And if you want to effectively record stained glass, either zoom in on the windows themselves, or underexpose the shot by 1 stop or more.

Low light interiors: Low light techniques can be applied to shooting interiors, too. Don't always go for the obvious: look upwards or downwards in interesting interiors to capture some extraordinary shots. Here, the view down the stair well of the Ponce de Leon Lighthouse near Daytona Beach in the USA makes an arresting shot.

86 SHOOT THE NIGHT SKY

Thanks to technologies such as the Hubble Space Telescope the wonders of the night sky have been revealed to us all. Spurred on by these, many photographers have had a go at astrophotography, but have been disappointed by their results. So here are some tips on how to get some interesting shots from the moon and night sky.

The moon is often the first target, but shooting using the camera's standard lens and Auto Exposure mode will result in nothing more than a bright patch of light in an otherwise black sky. Why? The moon is actually a lot smaller than we perceive, and also significantly brighter. Letting the camera determine the exposure means that it will take an average of the large expanse of dark sky that includes the small, bright moon. The final result is dramatic overexposure.

So how do you get a great shot of the moon? First you need to magnify your image as large as possible. That means using your camera's zoom lens at its maximum extent, or using a telephoto lens – a focal length of 300mm (35mm equivalent) will give you a reasonable size disc. Then set the exposure: as a start point, set your camera to ISO 400 with an exposure time of $\frac{1}{500}$ second at an aperture of f/5.6. Then shoot away!

Monitor the results in the camera's LCD and adjust accordingly to get the best ones. There are no hard and fast rules in astrophotography, so experiment with differing exposure times and apertures until you get the result you want. The moon can also add an interesting subject to landscape photos: in the late afternoon sky, with a bit of luck in positioning, you can zoom in to capture the moon with some landscape details below.

So what else can you do with your camera and the night sky? The other popular target is to shoot star trails. Point your camera, firmly mounted on a tripod, at the star-filled sky; working in a dark, rural location with no moon is best for this. Open the shutter for 5 minutes or longer, up to an hour. Whilst the shutter is open the stars will be recorded as they describe arcs around the sky, due to the rotation of the earth. This technique does require a camera on which you can hold the shutter open for extended durations – and keeping the shutter open can drain batteries very quickly!

The moon: It is comparatively easy to shoot detailed images of the moon using conventional telephoto lenses.

In the landscape: The moon can provide an intriguing addition to landscape shots.

Pro tip

THE MOON'S PHASES

Shooting the moon at a phase other than full can often provide more pictorial results. When full, the sun directly illuminates the moon and there are no shadows. However during other phases you'll get increasing amounts of shadow that provide a great range of contrasts. The luminosity of the moon reduces when only partly illuminated, so you will need to compensate with longer exposure times.

Moon phases: With less of the moon illuminated, more shadow detail and better contrast can be recorded.

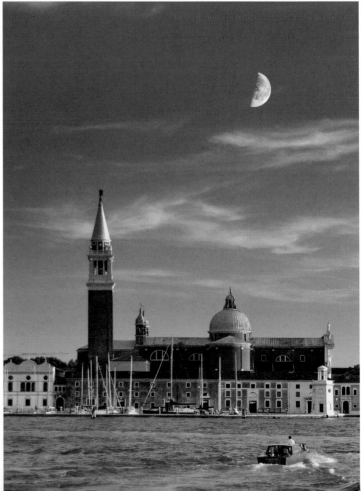

87 EMPLOY SOME SERIOUS ASTROPHOTOGRAPHY KIT

Do you want to take some jaw dropping shots of the planets and deep sky objects? In fact, this is not as difficult or as prohibitively expensive as you might imagine.

For great shots of deep sky objects – galaxies, nebulae and star fields, for example – you need to provide the camera with as much light as possible. This normally involves using a telescope with a moderate to wide aperture; also one that can follow the objects as they move across the sky – not producing trails as described earlier!

If you don't have access to a telescope, get in touch with your local astronomical society who will be happy to help you locate some suitable gear. Connecting the camera and telescope needs an adaptor; these are readily available from astro supply stores or again, your friendly society may have one you can use.

For low light, deep sky objects you'll be looking at exposures that last many minutes so, again, you'll need to know that your camera can handle these long exposure lags. Then, shoot away! Don't expect great results the first time you try this, but ultimately you'll get some absolutely compelling and stunning images.

Deep sky: This type of shot is a cinch with kit like the Nightscape CCD camera.

Pro tip

SERIOUS ASTRO KIT

Conventional cameras can produce some great astrophotographs, but they are not optimized for use under exceptionally low light conditions or for long exposures. If you've been bitten by the astro bug, why not invest in a purpose-built astrocamera? This is my favourite, the Celestron Nightscape CCD camera. It's designed specifically for shooting deep sky and other astronomical objects, and can deliver astonishing quality. I have to admit to being a great fan of Celestron kit – though they don't pay me to say so – and I'd recommend it unreservedly.

Celestron Nightscape CCD Camera (© Celestron): My favourite piece of astrophotography kit.

88 SHOOT THEATRE AND LIVE PRODUCTIONS

The opportunity to shoot theatrical productions or concerts can be a gift to the photographer. Lavish costumes, bold make up and sumptuous sets – even in the more amateur productions – give much scope for some great images. A production also lets you experiment, as conditions are controlled and, subject to a tolerant production director, scenes are repeatable.

> ### tip
>
> **VIBRATION REDUCTION**
> If your camera or camera lens is fitted with vibration reduction features, these will let you shoot in dimmer conditions, though they won't help you to freeze fast action.

Of course there are drawbacks. No theatrical or musical group will give free reign to a photographer leaping about in front of a paying audience as they go for the perfect shots. And shooting from your seat in the audience is not likely to yield photos that convey any of the sense of theatre. So how do you reconcile this? You could make friends with the company or performers, as the chances are they'll be looking for some great publicity shots or promotional photos. You could even offer to trade some free images for access to all areas.

Go to rehearsals so that you'll be familiar with the script and performances – the more familiar you are the better your chance of getting great shots. You'll learn to predict actors' or performers' movements and be in the right position to shoot set pieces.

How do you shoot meaningful shots of a performance? If you've ever taken photos at a show or even a pantomime, a straight shot of the stage will have been disappointing. Wide ranges of brightness and a strange mix of lighting will have conspired to render your shots lacklustre at best. And varying light levels can lead to longer than anticipated exposure times that can render shots unsharp if not downright blurred. We need to be a little more considered in our approach. Here's how:

- **Sensitivity:** Set your camera's ISO sensitivity high; consider a setting of ISO 800 or even ISO 1250. Your images will be a little noisier at high ISO settings, but generally this is an acceptable compromise for sharper shots.
- **White balance:** The strange mix of lighting conditions – colours and light sources – can confuse a camera's white balance. It's usually best to leave it set to auto and fix problems – if there are any – when viewing or printing.
- **Framing:** General views of the whole stage are OK if you've a big chorus line to

The bigger picture: Don't be afraid to zoom out for the full stage view when the performance demands. At wide angles camera lenses usually offer larger apertures and increased depth of field, resulting in sharper images.

ON YOUR PHONE
If you're in the audience of a show and armed only with a camera phone you can still get some good shots. Avoid the extremes of lighting by zooming in on the action or the characters. Ensure the camera phone's flash is turned off – you need to use the stage lighting, and a flash of light will both distract the performers and annoy your fellow audience members. Minimize shake by resting your camera on a firm support – a chair back or table can provide an impromptu solution.

shoot or a final curtain call, but can be a little too broad and – in a compositional sense – unfocused. Instead close in on the action. This is where an affinity with the production can help to get you to the best shooting positions.

- **Exposure:** When presented with wide brightness ranges you may need to underexpose shots slightly, say by $^2/_3$ stop. Using the exposure compensation feature is usually the best way to do this.

Not only will you have richer colours, but you'll also prevent the brighter parts of the scene from becoming over bright and featureless.

WATCH OUT!
Some productions don't allow photography. Don't put this down to a stuffy producer or cast, it is often for copyright reasons. A chat with the producers in advance will avoid any potential disappointment.

◁◁ Set piece: Knowing a performance inside out allows you to become familiar with specific episodes and provides you with the opportunity to grab shots like this.

◁◁ Stage snapshot: Cameras today are capable of handling difficult lighting conditions but can still be caught out by the extremes of stage lighting. A shot with a simple compact is fooled by the lighting and the vibrant (but intended) colour casts. And you get silhouettes of your fellow audience members' heads!

◁ Theatrical productions will try to emulate everything on stage from bright sunny days to dark gloomy locations. Adjust your camera's exposure to accommodate the scene, overexposing the brighter scenes (compared to the suggested meter reading) and underexposing the darker ones.

89 NIGHT AND LOW LIGHT PHOTOGRAPHY

As light levels fall our eyes acuity to colour falls, too; landscapes and cityscapes become dull and colourless. However our cameras don't suffer from such limitations and can help us shoot great photos even in the darkest of conditions. With our cameras at night we can even explore and record photos of astronomical phenomena, from the movement of the stars to elusive atmospheric spectacles such as the aurora, too.

Low light: As the sun sets, the scene transforms quickly. Shoot the brief window available.

ESSENTIALS

- Low light means long exposures – so make sure you've got a firm support for your camera to ensure sharp exposures at all times. Improvise by resting against something firm if you don't have a tripod or equivalent to hand.
- Take care focusing – at low light levels some auto focusing mechanisms may struggle to focus, or at least to focus on the subject you intended. Inspect your focus carefully and take care of it manually if your camera is struggling.

TAKE CARE!

- **Turn off your flash:** Your camera's flash may go off if you've not turned it off, which can be embarrassing for you and destroy the intended image.
- **Get the balance right:** Working at high ISO levels can introduce some digital noise. Take care to get the right balance between exposure time, aperture and ISO sensitivity to ensure the best image quality possible.
- **Reduce the aperture:** Lenses don't always give the best image quality when wide open; often you'll need to go to f/5.6 or f/8 for the best results. For great 'star' effects or bright lights you'll need an even smaller aperture, say f/11 or f/16.

EXPOSURE MODES

- **Auto mode:** This is great for getting a baseline exposure. However you'll need to dial in an exposure compensation of -2 or more stops to preserve the dark tones in the image. Also be mindful that this mode may not select a good, small aperture.
- **Manual mode:** Provides you with ultimate control over all elements of exposure. Use the LCD panel to review images and refine the exposure settings as needed.

Night-time reflections: Look out for colourful reflections in rain-soaked streets.

- **Night Portrait mode:** This is ideal when you need to combine a long exposure to record background landscapes or cityscapes with well exposed shots of subjects in the foreground.

IN YOUR KIT BAG

- **A firm support:** A tripod or equivalent; a mini tripod or clamp can be useful if you are travelling with minimal equipment.
- **Wide aperture lenses:** Prime lenses – those with a single focal length, as opposed to zooms – have wider apertures and fewer optical elements making them ideal for low light work.
- **Remote control:** When shooting long exposures, pressing the shutter can introduce vibration. Investing in a remote release can be wise if you intend to shoot a lot of low light photos.

GOOD TO GREAT TIPS

- **Experiment with white balance:** The mixed lighting of an evening or night-time urban landscape can comprise a mix of lighting sources that will be rendered in different ways according to the white balance selected. Use auto white balance as your default.
- **Bracket exposures:** More so than in other genres, exposure bracketing for low light photography will give you a range of images from which to choose the best. There's no right and wrong in low light work, so you can get different results from even modestly different exposure times.
- **Underexpose slightly to enhance sky colour:** Shooting with -1 stop can reveal colours in the evening sky that our eyes struggle to perceive at low light levels.
- **Carry a spare battery:** If you are shooting some very long exposures, the battery life of your camera can be compromised. Carry a spare or even two if you are planning an intensive shooting session. Moreover, if it's cold keep spare batteries in your pocket so they stay warmer; cold batteries will be limited in the power they can deliver.
- **Shoot abstract shots in the city:** Reflections of signage and neon in wet pavements and streets can produce more colourful and fascinating images than the signs themselves.
- **Recognize the power of black and white:** For atmospheric film-noir effects, convert your images to black and white; this can also solve problems of colour casts from mixed lighting.

A human angle: Sunsets make a perfect backdrop for silhouettes, as here.

CHAPTER 8: GETTING THE VERY BEST FROM YOUR SHOTS

Many photographers, especially those that are a little shy of digital technology, consider digital manipulation to be something of a cheat; they would argue that images should be conceived and perfected in camera. Perhaps they are thinking back to the days of film photography, as this partisan view is not borne out by the facts. Traditionally, images shot on film often required the skills of a practiced darkroom worker if they were to really deliver. Digital technologies have merely made those skills more accessible to the rest of us.

True, digital image manipulation can – and does – produce some weird and wacky results when the tools are used to their extreme or special effects are employed. But then, didn't some of us achieve the same when we used those (in retrospect) absolutely absurd filters on our camera lenses? Let's not get into an argument on the pros and cons of image manipulation. Instead, let's go back to the ethos of this book. We're looking to make good photos great, and if that means we need to use some deft digital techniques, perhaps to fix things that were beyond our control in camera, I'd say that was OK.

In this chapter we will look at some contentious areas of image manipulation – sharpening, for example. Images should be sharp in the camera and we should not need to resort to any post processing to correct deficiencies. Yet we do live in the real world and sometimes, despite the best intentions, we don't get things 100% right. Image manipulation, though, is just the means to an end; that end is a great photo or great portfolio to justifiably show off. So we'll close with some ideas and inspirations for making the best of those images that we have worked so hard to create.

90 SUCCESSFULLY SHARPEN AN IMAGE

There's nothing more disheartening than to find an otherwise great shot isn't pin sharp when you inspect it closely. Image manipulation software can come to your aid and rescue that shot – but using sharpening tools does need the application of some discretion.

When digital manipulation software in the form of Adobe Photoshop first burst on to the scene, photographers let out a collective shout of delight. No longer did they need to be critical – or so they believed – of their composition, colour fidelity or, perhaps significantly, their focusing in camera. It could all be sorted later digitally, using a sharpening tool. Under closer scrutiny though, it could be seen that sharpening a soft image might give the impression of better focus, but that it was impossible to restore any fine detail that, due to less-than-perfect focus, was not there in the first place.

So, should we dismiss sharpening tools? Absolutely not – but they do need to be used with discretion. I stick to using the Unsharp Mask, a sharpening tool that many people shy away from because of its seemingly obscure controls. However get to know it – and it's settings – and it's the only sharpening tool you'll ever need. The three controls of Unsharp Mask are Amount, Radius and Threshold, and can be explained as follows:

- **Amount:** This simply describes the amount of sharpening applied. It can be varied from the slightest hint to levels so extreme you'd never actually use them.
- **Radius:** This describes how the sharpening is applied. A small radius means the sharpening is applied over a very narrow distance, a larger amount over a broader distance.
- **Threshold:** This defines the difference in tone before sharpening is applied. If this is set too low, the Unsharp Mask algorithm will attempt to sharpen fine differences between adjacent pixels – such as those on the skin – to produce a rather grainy, flat result.

If these controls still seem a little obscure, don't worry. Try these base settings and adjust should you need to. Vary the Amount according to your image size; these figures apply to an image from a 12-megapixel camera, so add more for larger images.

Subject	Amount	Radius	Threshold
Soft, feminine portraits	140	1	8
Children and male portraits	100	2	4
General sharpening	100	1	2 to 6

Unsharp Mask: Applying a modest amount of Unsharp Mask can increase the perceived sharpness in an image. Look closely – the result

Too much: Apply too much sharpening and your image will quickly degrade.

WATCH OUT!
Apply too much sharpening and your heavy-handedness will be instantly betrayed. Less is certainly more! If an image requires an excessive amount of sharpening it's probably too blurred to rescue.

91 USE AUTO FIX CONTROLS – WITH CARE

Auto Enhance, Auto Fix and Auto Tone – call them what you will, yet these tools are designed to quickly pep up an image. However like sharpening tools, they need to be used with discretion.

Many baulk at the suggestion of using auto fix tools in image editing applications. And they are right to have concerns; like Auto Exposure mode in your camera, such auto commands make presumptions about your images. For example, Auto Tones assumes that an image should have a distribution of tones from the brightest white through to the deepest black. Should the image submitted not have that distribution, it will adjust accordingly. In most cases this will pep up the contrast and give a flat image punch.

However, should your image deliberately feature a skewed mix of tones, the result can be dramatically wrong. So, should you use it? If this adjustment works and delivers a great image, yes. If not, opt instead for alternate quick fix controls such as Auto Contrast, which (perhaps obviously) adjusts contrast, or try Auto Colour, which adjusts the colour distribution. If they don't work for your image then just don't apply them, but as short cuts for when you are in a hurry, they can create some really punchy images.

Pro tip

DISCOVER THE LEVELS FEATURE
You can overcome the brusque nature of the Auto Tone command by getting to know the Levels feature. Under your control you can set the white and black points, then adjust the position where the mid-tone levels should be.

Auto Tone: When it works, Auto Tone can give an image an immediate lift – but you need to look closely at the authenticity of the result.

Cloudscape: The limited tonality of a cloudscape means that using Auto Tone will have a dramatic and inappropriate effect.

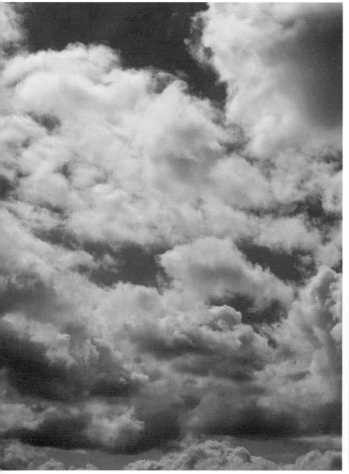

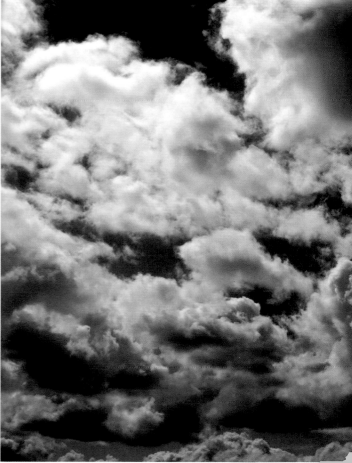

92 TRANSPLANT A BETTER SKY

You can feel very satisfied when you've conceived and shot what could be a winning image. But often events – and in particular the weather – can conspire to take the edge off the shot on close inspection. Do you resign yourself to accepting the inevitable, or resort to a little digital sleight of hand?

Of course, it's the latter! After a period of bad weather, a spell of sunshine can be a panacea and provide the impetus to get out with a camera. But it can be a mixed blessing: a clear blue sky can be somewhat featureless, throwing your shot out of balance. What you need is a sky replete with some bold, structural clouds, so learn how to transplant one from one image to another. Sound's difficult? Actually it's surprisingly simple, though, like most techniques, a little practice will help develop your skills. Here's how to set about it:

1. Use the Magic Wand tool to select the problem sky area. Often you'll not be able to do so with a single application of the Magic Wand, so instead will need to make multiple selections.

2. Select a second photo with a sky in it that you can use, making sure it's appropriate for the scene (see Watch out!). Open this in your image manipulation application and select the whole image. Now copy the image to the clipboard; this is usually done by selecting Edit menu >Copy.

3. Return to your original landscape image and select Edit >Paste Into. In some applications like the latest versions of Photoshop this is Edit >Paste Special >Paste Into.

4. You'll now see your new sky in place. Most likely the sky won't precisely match the selection, so use Edit >Transform >Scale to adjust the scale to fit.

5. That's it – although you may want to adjust the transparency of the new sky to make it match the scene. Use the Fade command to slightly reduce the brightness if it is too bold.

WATCH OUT!

It's important that any transplanted sky looks realistic. A bright blue sky replacing an overcast one will only produce a surreal image. Make sure that you match the sky to the scene – in particular that you match the angle of the sun.

Pro tip

CLOUDSCAPE LIBRARY
When you see an interesting sky, take a few shots in different directions so you can match the angle of the sun with that in your shot. You'll soon build up a library, providing you with the resource to add the most appropriate sky to any photo that needs it.

△ Donor sky: Here's the transplanted sky that was donated to the landscape image.

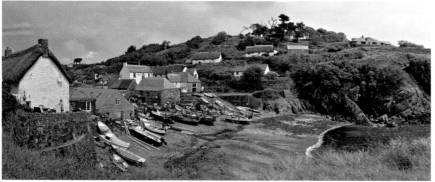

◁ Original landscape: A nice scene, but a disappointing sky.
▽ Final image: Introducing a sky from another shot produces a more interesting image.

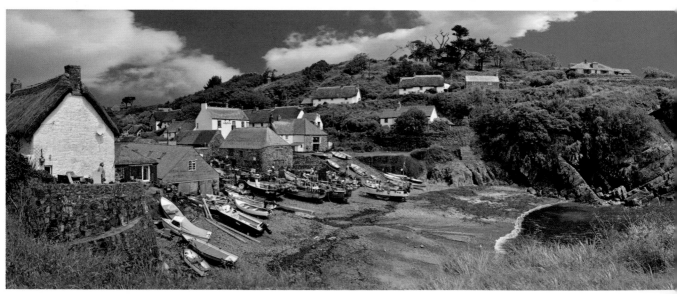

93 PUSH THE BOUNDARIES OF REALITY

Once you've mastered the technique of pasting new skies into existing images, take one step further and create scenes that might never exist – or be possible to shoot – in the real world.

When conceiving such shots you need to decide whether you want to produce something that's obviously absurd or is just stretching reality a little. Here's an example of the latter: it's a shot of Concorde in flight, shot from one of its delta wings. Of course, I did not shoot this for real. For one, it was shot long after the aircraft was decommissioned; second, this shooting position is completely unviable for this plane!

The process to produce this shot was substantially the same as that used for the simple sky transplant (see Transplant a better sky). The Magic Wand tool allowed me to select a fair part of the Concorde scene that required the new sky, but it proved easier to precisely define the aircraft using the Magnetic Lasso tool. It can often be quicker to use a combination of selection tools, particularly when selecting irregular areas or those with extreme tonal ranges.

In the air: With a new sky transplanted behind Concorde the result is rather convincing!

On the ground: Concorde shot on the ground, from the ground, at a static exhibit at its home in Filton, near Bristol.

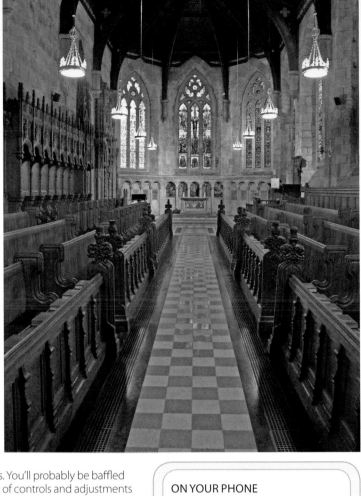

Chapel: The type of Image where HDR can come to the rescue, with bright windows and deep shadows. An HDR composite comprising of three images – one underexposed, one overexposed and a straight exposure – produces a shot with better rendition of both bright and dark areas.

94 CONTROL EXTREME CONTRASTS WITH HDR

HDR (high dynamic range) is a popular technique that combines multiple, bracketed exposures to create an image where extreme contrasts in the original scene are compressed to fit the range of a digital image.

When HDR was discovered, comparatively recently, the photographic press and websites were suddenly overwhelmed with shots that fell into this category. As is so often the case when a newly popularized technique is discovered, the photo editing mantra 'less is more' was cast aside, resulting in some rather garish shots.

This is something of a shame as HDR is the perfect solution for shots that might otherwise fail. True, there are mechanical ways that excessive brightness ranges in a scene can be handled, but although some cameras can automatically shoot the component images and amalgamate them in camera, the best way to approach HDR is to shoot and combine the shots yourself.

For this you'll need: a camera (that can shoot in RAW mode), a tripod (essential support for consecutive images) and combining software (Photoshop and Photomatrix are amongst those that offer this feature). With the camera firmly mounted either manually or automatically, take a series of shots: the first at the correct exposure, the next 1 stop overexposed, then 2 stops overexposed, 1 stop underexposed and 2 stops underexposed.

Upload these to the HDR feature in your image manipulation software and follow the instructions. You'll probably be baffled by the number of controls and adjustments you'll see first time around, but don't be – just click your way through, almost on autopilot, the first time. Alternatively, have a play with the controls and observe the effect on the image. Again gentle adjustments, although providing more modest results, will produce more realistic ones.

tip

RAW FORMAT
The RAW format is simply an image file stored directly from your sensor. No post processing – like white balance adjustments – is applied as they are to JPEG and TIFF format files. RAW images can look dull when viewed directly, but as they are untainted by any adjustments you can apply any corrections without compromising the image quality – ideal for drawing the finest quality from the image, as in HDR.

ON YOUR PHONE
Several camera phones, including iPhones, can shoot HDR directly. The finished HDR image – but not the component shots – will then be displayed and saved. The results will generally be good, though you'll lack the ability to adjust the image.

Auto HDR: These iPhone 4 images comprise a standard shot and the HDR version, produced in camera.

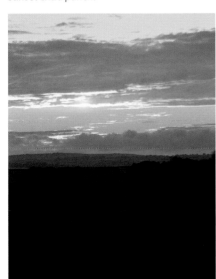

95 CONTROL EXTREME CONTRASTS WITH SOFTWARE

Reducing the brightness range in an image is not the preserve of the HDR technique. You can achieve a similar result using the Shadows/Highlights command.

Shadows/Highlights is something of a quick hit tool, without too much in the way of controls but, on the upside, it can be used with any image type, not just RAW. Moreover you can apply it to a single image, rather than a bracketed set. In Photoshop you'll find Shadows/Highlights in the Image >Adjustments menu.

In the default mode, this command has a pair of simple sliders that allow you to lighten the shadow areas or darken the highlights in an image. These will initially apply a rather bold effect, so it's worth reducing the impact somewhat to achieve a more modest HDR effect.

In the extended mode (click on Show More Options to reveal the controls) you can also apply changes to the colour or contrast that might have been introduced when applying the lightening and darkening, and there are additional controls for the Highlights and Shadow settings. Adjust the Tonal Width control to extend the range of tones that are lightened or darkened, then use the Radius slider to fine-tune the results.

Shadows/Highlights controls: Simpler than those of HDR and perfect for applying some quick fixes.

Faux HDR: Shadows/Highlights applied (at 15%, Shadows) to a sunset scene. Exposed for the sky, the landscape was rendered too dark in the original image. The colour saturation has been boosted by the controls to give the sunset extra punch.

96 CROP YOUR PHOTOS FOR IMPACT

Cropping a photo by trimming away any superfluous parts is a simple way to make a good picture even better. Whether you work purely digitally or prefer to use a pair of scissors, it's a simple skill to master.

The more accomplished a photographer you become, the better you will be at composing your photos – making sure the subject is properly placed in the scene. However sometimes you can't get the shot quite right, so trimming away the edges can really make it. By selective cropping, a so-so image can become a truly great one, removing any peripheral parts that might be distracting.

Image manipulation software makes cropping of digital images even simpler still. Like the cropping cards, the Crop tool places an overlay (normally by dimming the surrounding parts) across the photo making it easy to judge the effectiveness of the crop. You can use the handles (the little squares around the edge of the central image) to adjust the shape of the crop to get the result just right.

When you are happy with your crop, hit the appropriate button to accept and the now-superfluous surroundings will be trimmed away. Job done! While we're on the subject, here are some more tips for cropping your images:

- **Square shape:** Most of our photos tend to be rectangular but don't be afraid to crop your images to a square shape if you like the result.
- **Save a copy:** Save a copy of your original image prior to cropping, just in case you want to return to the uncropped version some time in the future. With the Crop tool there's no going back!
- **Don't overdo it:** Don't crop down to a very small part of the image unless your start image was high resolution; this will avoid disappointingly poor resolution when the image is enlarged and printed.

Cropping cards: Although they predate digital photography, cropping cards are still used by many photographers to adjust the crop on printed images. Simply 'L' shaped pieces of card, you can lay them over a print to see what the cropped version might look like before resorting to cutting.

Cropping lines: The virtual cropping lines in image editing software make it easy to precisely position the boundaries prior to cropping.

Cropped image: This portrait of a Roman artisan was originally composed to show her studio, too. The Cropping tool has stripped away the superfluous and distracting parts of the original photo according to the rule of thirds for a pleasing finish.

97 DISPLAY YOUR PRINTS LIKE A PRO

There have never been more great opportunities or options to get your best shots printed and mounted for display. But which are the best ones? For this, it's worth taking a cue from professional photographers and art galleries.

When we come to show our photos we can fall victim to two faux pas. Firstly, showing our photos at too small a size: great images are designed to be printed and seen at a large size so that you can stand back and appreciate them, then get up close to examine the attention to detail. Secondly, there's often a risk of gilding the photographic lily by mounting a print in a frame that vies for, and often wins, the viewer's attention. Just think of those golden swept frames that that would serve a more fulfilling purpose

providing the home to an ebullient Monet or Cezanne painting.

To present a photo at its best you need something simple that complements rather than competes. For me that has always meant the gallery frame, a simple square section wooden moulding, stained black or (exceptionally) white; the print itself is presented in a simple bevelled mount that provides a modest plain white border. This display apparatus is what, as the name suggests, the great galleries use.

Some photographers add a slight embellishment to this display in the form of a second, inner mount – usually black – that provides a fine dark 'key' line around the print; this is particularly useful for defining the image if your print is predominantly light. And what about the size? This depends on the subject (some portraits can look scary really large!) but consider A3 (11¾ x 16½in) as a good print size for your best prints.

Mounting prints: Bold but simple mounting directs all the attention to your prints. You've worked hard to create brilliant photos, so you need to show them off to best effect.

98 DISPLAY YOUR PHOTOS ONLINE

Viewing images online is a different experience to viewing printed ones. Computer, tablet and phone screens tend to enhance contrast, making images punchier; they will also render the images less sharp, as the resolution of the screen will be significantly less than that of photographic paper. So how can we best present our images online?

Interestingly, the higher contrast of screens goes some way to negating the loss of resolution on a computer screen. Moreover, for presenting images on screen there is now a range of easily accessible options of varying complexity. The quality and the choice will inevitably be determined by the nature of our images and the intended audience. Here we'll compare some of the more popular options.

Simple websites: Using Weeble, WIx, Wordpress or other resources, you can quickly create a website to show off your best images – often using simple-to-populate templates.

GREAT SOLUTION: CREATE YOUR OWN PHOTO WEBSITE

Pros
- You retain complete control over how your images are displayed.
- You also have control over quantity and resolution.
- There is potential to build in a web shop to sell your images.

Cons
- This requires a degree of skill.
- You'll need to manage the site yourself.
- You'll need to promote and advertise your site to bring traffic to it.

GOOD SOLUTION: SHARING YOUR PHOTOS ON FLICKR

Pros
- This is solid, photo-focused web resource.
- Good image quality.
- It is free to use, for a limited number of uploads.
- It is easy to create folders and albums.
- Tools allow you to export images from apps such as iPhoto.
- Images can be tagged so that others can search for your images.
- Great for peer review of your images.

Cons
- All images are resized to fit.
- You need a modest paid 'pro' subscription for unlimited uploads.
- You can't sell your images via the website, though images can be sold via Getty Images.

PRETTY GOOD SOLUTION: GALLERIES AND SLIDESHOWS ON FACEBOOK

Pros
- Great for sharing images quickly with friends and family.
- Good image quality.
- Unlimited storage space.
- Opportunity to comment on individual photos.
- Free and easy to use.

Cons
- Not easy to download images.
- Medium image quality.
- You must follow Facebook's rules.

99 PRODUCE PERFECT PRINTS

When it comes to printing images that look at least as good in print as they did on your computer, you will need to carefully assess the options available to you.

Colour casts: Dominant hues and/or deliberate colour casts can be difficult for automated machines to print and should be done on a home printing system. The insert here shows how a machine printer would render the scene.

tip

ALTERNATE DISPLAY METHODS
Print technology now means you can print your best images to almost any surface, for example: canvas prints, great for classic portraits and landscapes; boxed prints, best for informal portraits and graphic images; and acrylic prints, perfect for images rich in bright, bold colours. However just because you can print to almost any surface doesn't mean you should. An image that looks great as a wall hanging may not look so good on a mug or a mouse mat.

Rich tones and details: Choose a printing paper surface that will best represent the subject, such as glossy paper for rendering fine details.

GREAT SOLUTION: USE YOUR OWN PRINTER

Pros
- You retain complete control.
- You can choose from a wide range of printing paper surfaces.
- It is easy to adjust colour and contrast parameters for the best print.

Cons
- Not always the cheapest option.
- Usually limited to a maximum size, a little larger than A3 (11¾ x 16½in).
- Larger printers are more expensive (to buy and run) and take up more space.

GOOD SOLUTION: ONLINE PHOTO PRINTING

Pros
- It is easy to upload to printers' websites.
- A wide range of print sizes is available.
- This is an efficient process for large quantities of prints.
- These sites have an extensive range of additional printing services – printing on special surfaces, fabrics, etc.

Cons
- You'll work blind: any difference between your onscreen image and printed image won't be seen until you receive a print.
- There's a finite delay between ordering and receiving prints.
- It can be more expensive, depending on the products ordered.

PRETTY GOOD SOLUTION: PHOTO STORE PRINTING

Pros
- Convenient – kiosks are located in photo stores and supermarkets.
- You can make limited edits – crops, colour corrections, etc. – on the spot.

Cons
- The price is often higher than home or online printing.
- Some stores only offer limited printing facilities – up to A4 (8¼ x 11¾in) – on the spot.

100 MASTER IT ALL – AND FIND YOUR STYLE

And so we come to the end of our adventure, or our first adventure. Along the way we've looked at ways of shooting some great photos and taken a look at some classic faux pas. Let's conclude by looking at where we go next. You may be happy just taking better photos, but you may want something more – to develop a personal style that sets your work apart from that of others.

There are some photographers whose style is immediately obvious: consider Ansel Adam's landscapes, which boast deep, rich skies and remarkable tonality, or Annie Leibovitz's portraits. For me the most intriguing style is that of Martin Parr, whose documentary photographs take a wry, critical look at life in the UK and are instantly recognizable.

Many of us have already taken a number of steps that has set our work apart from the crowd. Hopefully, as you've read through this book, you've taken some more. Your photos will immediately be spotted amongst your peers as 'the good ones'. Those peers may not be able to put their finger on what makes your photos stand out, but it's most likely a mix of correct exposure and considered composition.

However developing this personal style is perhaps something that you'll find happens on its own. As your prowess grows you'll find that certain techniques and certain subjects become more appealing. You'll become more critical of photos of those subjects that you shoot, and you will constantly strive to shoot better and better ones.

This process can become almost obsessive and if you are anything like me, you need to periodically take stock. Take a look back at the photos you used to take and compare them. Appreciate objectively how your shots have improved, as it's easy to underestimate how good your photography has actually become.

However if there's one bit of advice I'd like to leave you with, it is to never forget that photography should be fun and inspiring. Fun because it's something you want to do; inspiring because you'll never grow tired of that moment when you return home, download your images, and see what great ones you've captured!

Balloon G-CHBX: I find colour and form compelling – which is why my portfolio is packed with subjects like balloons. Shot from below, they can be visually more striking and produce endless combinations of shape and colour.

Towards a style: Whether you enjoy shooting anything and everything, or are a bit more circumspect, you'll be surprised by how quickly a style develops. Perseverance and dedication will be rewarded as you begin to take exposures that are consistently spot on, as you recognize often-fleeting compositions and as you successfully make use of unusual lighting conditions.

JARGON BUSTER

Taking great photos is an art – though as I've said earlier, science has a part. And that means a bit of jargon can creep in. So, in case you've missed the explanation, or I didn't have the opportunity to give one, here's a glossary of some of the most common photo terms:

- **Angle of view:** The angle of a scene that a specific lens covers, measured across the diagonal of the frame. Wide-angle lenses offer a wide angle of view (the name was a give away) while telephotos offer narrower and narrower fields of view with increasing focal length.

- **Aperture:** The opening in a lens that allows light through. It is controlled by an iris (rather like that in an eye) under manual or camera control and is varied along with the shutter speed and the sensor sensitivity (ISO sensitivity) to achieve correct exposure.

- **Aperture Priority mode:** An exposure mode where the photographer selects the aperture and the camera will set a corresponding shutter speed.

- **Automatic exposure:** A camera exposure setting where the camera assesses and sets the aperture, ISO sensitivity and shutter speed according to the ambient shooting conditions.

- **Automatic flash:** Electronic flash that is activated automatically when light levels fall. Normally this can be overridden to prevent the flash from operating when it is not required.

- **Back-lit, back lighting:** A shot lit by a light source behind the subject, facing the camera and that usually requires exposure compensation (or fill-in flash) for accurate exposure of the subject.

- **Depth of field:** The distance between the nearest and farthest points that appear in acceptably sharp focus in a photograph. Depth of field varies with lens aperture, focal length, and camera-to-subject distance.

- **Exposure:** The amount of light falling on the image sensor of a camera when taking a photograph. Varied by adjusting the aperture, the time the shutter is open and the ISO sensitivity.

- **Exposure compensation:** The adjustment of a metered exposure to allow more or less light through to the

sensor in order to compensate (usually) the brightness or reflectivity of the subject.

- **Exposure/focus lock:** A feature found on some cameras that allows the exposure settings or the focus to be locked by pressing either the shutter release partially, or depressing a separate button.

- **Filter:** A piece of optically transparent material placed over the lens of a camera to modify the incoming light by colouring, diffusing or restricting the light entering the lens. Also a term used to describe digital effects that modify images in a similar way (or often, in more extreme ways).

- **Flash, fill-in:** A burst of electronic flash used in bright lighting conditions to prevent dark shadows in subjects. Needs to be accurately balanced with the ambient lighting for best effect.

- **Focal length:** Normally stated in millimeters, this is the distance between the centre of the outermost lens element of a camera lens to the imaging sensor when the camera is focused at infinity. The focal length also determines the angle of view of the lens and the amount of a scene that can be included in one shot.

- **Focus:** The point where the light rays from a subject are brought together to form an image.

- **F-stop, f-number:** A setting of the lens aperture. Normally consecutive f-stops are factors of 2 of the aperture opening (f/4 is half the aperture of f/2.8, for example). The f-number is often used to describe the maximum aperture of a given lens.

- **Graduate, graduated filter:** A lens filter that darkens towards the top. Used to even out lighting levels in a scene with bright skies.

- **HDR:** High dynamic range is a technique that uses multiple bracketed exposures to reduce the brightness range in a scene

so it can be accommodated within the limits of a digital image.

- **Image manipulation application:** Software designed to manipulate and edit digital images. Photoshop is the most renowned of these.

- **Image sensor:** Think of this as digital film – the part of a camera that records the image.

- **ISO, ISO sensitivity:** This is used to denote the sensitivity of film and the equivalent sensitivity of an image sensor. Higher numbers indicate proportionately higher sensitivity.

- **Landscape mode:** An image recorded in horizontal format (compare with portrait mode).

- **LCD Monitor screen:** The screen found at the back of digital cameras used to preview images and review photos recorded by the camera.

- **Macro:** Term used to describe reproduction where the image size is the same, or larger, than the original object. Tends to be more loosely used in digital cameras for extreme close ups.

- **Macro mode:** A switchable lens mode designed to allow photography of small objects at a large scale (see Macro).

- **Multiple exposure:** A single image comprising two or more image exposures that have been superimposed in camera.

- **Noise:** In digital photography, this describes interference produced by random fluctuations in an electronic circuit. Most obvious in digital images recorded using high ISO settings.

- **Optical viewfinder:** Camera viewfinder that relays an actual image (rather than an electronic image) to the eyepiece.

- **Overexposure:** Allowing too much light to reach a sensor, compared with the assessed exposure. May be

done accidentally, or intentionally for creative purposes.

- **Panorama:** A photograph that has an aspect ratio wider than that of a conventional image sensor and a particularly wide (up to 360 degrees) angle of view.

- **Panoramic mode:** A digital camera mode that allows multiple shots to be conjoined to produce a wide (or a tall) panoramic shot.

- **Photoshop:** The leading application used by virtually all professionals and enthusiasts, priced accordingly. A trimmed version, Photoshop Elements, provides much of the same functionality at a lower price.

- **Polarizing filter, polarizer:** A lens filter that cuts out, or reduces, polarized light. Used to deepen sky colours and cut out reflections, it is one of the few filter effects that is difficult to reproduce by digital image manipulation.

- **Portrait mode:** A photograph (not necessarily a portrait) shot with the longest dimension upright (compare with Landscape mode).

- **Program mode:** An automatic exposure system where aperture and shutter speed are set according to a program optimized for the majority of shooting conditions.

- **RAW format:** An image format produced by digital cameras that does not impose any compression or post processing, allowing the photographer to extract the maximum quality and information.

- **Scene modes:** Preconfigured camera settings that, when selected, set camera controls to their optimum settings for specific subjects. Examples are Landscape, Portrait and Sports. For each case the focal range, lens aperture and exposure time will be configured to enable the photographer to get the best results automatically.

- **Shutter speed:** The length of time the shutter is kept open to allow an image to be formed on the image sensor.

- **Shutter Priority mode:** An exposure mode where the photographer selects the shutter speed and the camera automatically sets the aperture, ideal for action and fast moving subjects.

- **Spot metering:** Metering mode where an exposure reading is made from a small discrete area of the scene, normally indicated by a circle at the centre of the camera's viewfinder.

- **Telephoto lens:** A lens with a long focal length that has a narrower angle of view than a standard lens or the human eye.

- **Underexposure:** Intentional or accidental decrease in exposure resulting in less light arriving at the sensor than an accurate exposure would suggest.

- **White balance:** A camera control that ensures the colours in a scene are accurately reproduced no matter what the lighting conditions. Can be disabled if a photographer wants to introduce deliberate colour casts.

- **Wide-angle lens:** A lens with an angle of view wider than a standard lens. Those with an even wider angle of view are sometimes called super wide, and those wider still are called ultra wide.

- **Zoom lens:** A lens that allows you to change focal lengths (and image magnification) continuously between wide angle and telephoto (usually).

INDEX